IMAGES
of America

KINSTON

Dear Daniel —
From one author to another,
you're definitely that great.
Looking forward to a long
and prosperous friendship.
Sincerely,
Nina

IMAGES
of America

KINSTON

Nina Moore

ARCADIA
PUBLISHING

Published by Arcadia Publishing
Charleston, South Carolina

Printed in the United States of America

Library of Congress Catalog Card Number: 2002103972

For all general information contact Arcadia Publishing at:
Telephone 843-853-2070
Fax 843-853-0044
E-mail sales@arcadiapublishing.com
For customer service and orders:
Toll-Free 1-888-313-2665

Visit us on the Internet at www.arcadiapublishing.com

CONTENTS

ACKNOWLEDGMENTS

For as long as I can remember I have dreamed of writing books. However, I never dreamed that my first book would be on Kinston. After working on this book for several months, I realized that it is only fitting that I give back to my community what it has given to me. I give a sincere thank you to the people of Kinston who have made this book possible.

Heritage Place at Lenoir Community College provided the bulk of the pictures in this publication. Thank you to the staff for all of your help and patience, and thank you to the people who donated their pictures, realizing their historical value. The North Carolina Collection at the University of North Carolina at Chapel Hill and the North Carolina Department of Archives and History also provided several pictures. Thank you to those people who work so carefully to preserve our state's history.

Also, I am very grateful to the Free Press for their coverage of this project. I felt so flattered to have people call me in Chapel Hill to tell me my picture was on the cover of Monday's newspaper. Several individuals donated their pictures to the book and for that, I am truly grateful. They add a special touch that could not have been accomplished without them. Thank you so much to Judy Carey, Marianna Lewis, Sue Rouse, Wilbur King Jr., William Wilder, Jimmy and Juanita Hayes, and Frances Lipscomb. Pat Faulkner and Jan Barwick also helped me with this project, and I thank them for their contributions and patience as well.

Finally, there are some very important people that have been left out. First of all, the staff at Arcadia Publishing Company in Charleston, South Carolina, deserves much credit for making this book possible. After trying to find an author for months, they stumbled upon me as an intern from Kinston. They never hesitated in providing me with the opportunity to be one of their authors, despite my youth. I am truly grateful to everyone there for making not only working there such a great experience but for giving me this opportunity. Laura, my faithful editor, I truly appreciate all of your advice, time, and patience.

My family and friends have provided the support that I have so desperately needed throughout this project. Not only have they shown their love and encouragement my entire life, but they have been especially wonderful as I have worked on this book. This has been my pride and joy, and I am so grateful to everyone that helped along the way. I hope this proves to be something that everyone in Kinston may enjoy for years to come.

INTRODUCTION

An old folktale about Kinston says that if you drink from the fountain (which used to be downtown) you would always come back. This seems to have proven itself true in many instances. Some of the families who helped start and develop this town still reside in here Kinston today—more than 200 years later. The roots of Kinston's heritage run deep and are rich in history and progress.

According to *The Heritage of Lenoir County*, an act by the General Assembly in December 1762 established Kingston. Therefore, it exists as one of the oldest towns in the state today. The first two streets were named King and Queen in honor of King George and Queen Charlotte. The Neuse River provided the western boundary with the other boundaries being East, North, and South Streets. The trustees of Kingston were honored with streets named after them—Caswell, Gordon, Bright, McIllwean (McLewean), and Shine. Streets were also named after Governor Dobbs (later Independent Street) and William Heritage. In 1784, the name was changed to Kinston due to ill feelings towards the king.

Many of Kinston's finest citizens participated in the Revolutionary War, the Civil War, World Wars I and II, the Vietnam War, and the Korean War. Some of our men and women are fighting now to preserve our rights and liberties. Strong and courageous, Kinston citizens have struggled to progress and to keep our town thriving. Good land and good people have made this place our home, and I believe it is a good one.

One

PIECES OF HISTORY

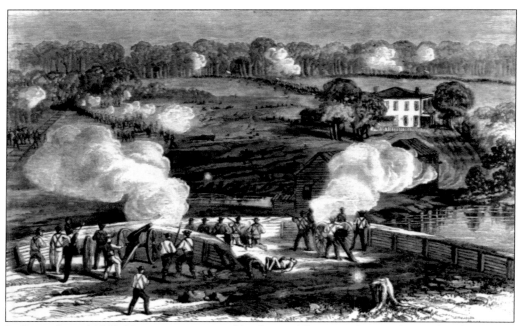

In December of 1862, Kinston was targeted by General Foster to destroy the vital Wilmington-Weldon Railroad Bridge across the Neuse River in Goldsboro. Kinston fought two important battles during the Civil War and many heroic citizens gave their lives. (Courtesy of the North Carolina Collection, University of North Carolina at Chapel Hill.)

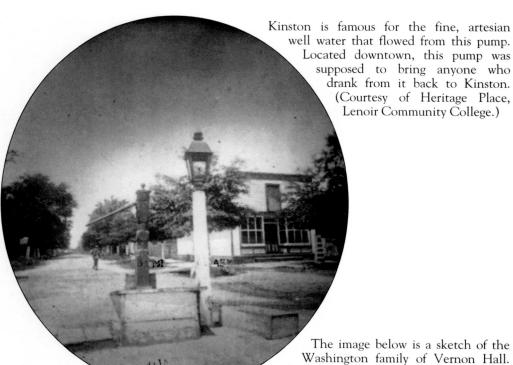

Kinston is famous for the fine, artesian well water that flowed from this pump. Located downtown, this pump was supposed to bring anyone who drank from it back to Kinston. (Courtesy of Heritage Place, Lenoir Community College.)

The image below is a sketch of the Washington family of Vernon Hall. (Courtesy of Heritage Place, Lenoir Community College.)

William Donnell Cobb (1805–1865) was part of the influential Cobb family who were one-time owners of Harmony Hall. (Courtesy of Heritage Place, Lenoir Community College.)

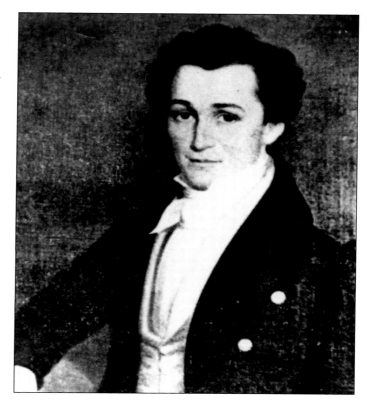

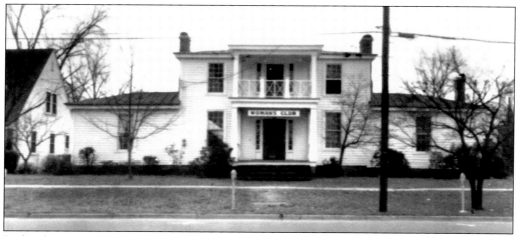

Richard Caswell, North Carolina's first governor, occupied Harmony Hall during the late 1700s. One of the first secretaries of state, James Glasgow, also lived at this historical residence. During the Civil War, it was used as a Confederate Hospital, and it served as a library for Kinston in the 1930s. (Courtesy of Heritage Place, Lenoir Community College.)

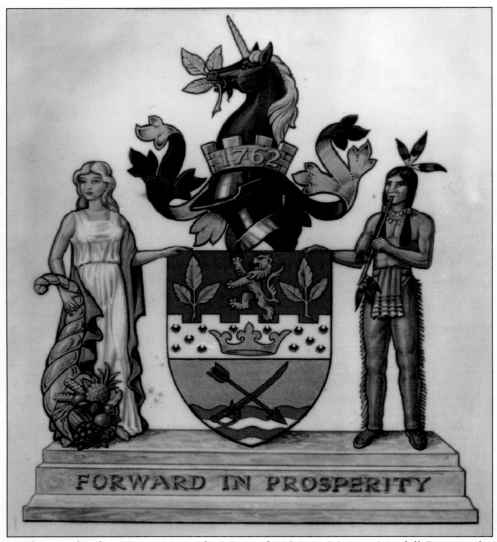

FORWARD IN PROSPERITY

According to the description written by Meriwether Lewis, Marion Arendell Parrot, a local lawyer and officer of parachute artillery, was stationed in England during World War II. During this time, he was fascinated by the fact that all of the towns in England had their own Arms, Seal, and Flag. Since Kinston would soon celebrate its 200th anniversary, Parrott, in 1958, began to attempt to get Kinston its own Arms, Seal, and Flag. In 1960, for the first time in its 500 years of existence, the College of Arms in London, England, presented Armorial Bearings to a town in the United States in America, Kinston. The Blazon of the Armorial Bearings, as shown here, can be found also in the seal of Kinston. The crown in the middle represents Kinston's original name of Kingston in honor of King George III. The gold lion symbolizes courage and fortitude, and the two sprigs of golden tobacco refer to Kinston's principle industry. Reminiscent of the Tuscarora War, a sword and an arrow are crossed on the bottom. The blue and white waves under the crossed sword and arrow are the River Neuse upon which the Town of Kinston is situated. The female figure on the right holds a cornucopia, representing prosperity, and on the left stands a Native American, a brave of the Neuse Tribe, smoking a "pipe of peace." (Courtesy of Marianna Lewis.)

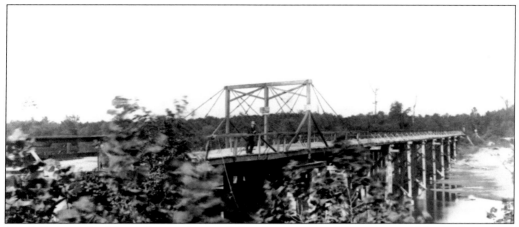

Nestled along the Neuse River, the small Southern town of Kinston would later play a very influential role in the state of North Carolina. In 1894, a soldier fighting in the Civil War took pictures of Kinston because of its beautiful landscape. He photographed the Neuse River Bridge as a man peered over, watching the water roll by. (Courtesy of the North Carolina Department of Archives and History.)

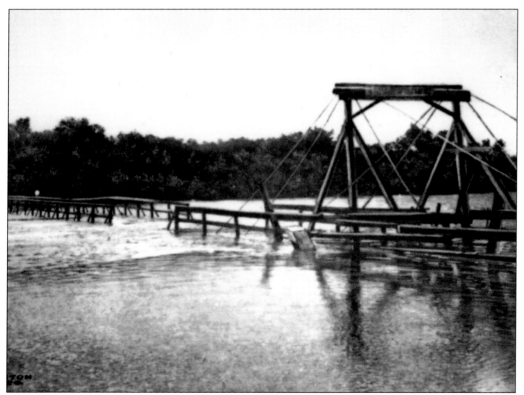

During a period of high water in September of 1908, the Neuse River flooded Parrott's Bridge. (Courtesy of Heritage Place, Lenoir Community College.)

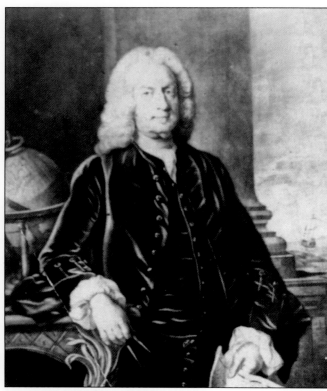

Gov. Arthur Dobbs purchased a tract of land at Tower Hill from James McIllwean with hopes that the seat of government of North Carolina would soon be established along the Neuse River. (Courtesy of Heritage Place, Lenoir Community College.)

Tower Hill was the appointed capitol of North Carolina from 1758 to 1762. William Heritage, who served as clerk of the General Assembly for 30 years, owned the property from 1707 to 1769. (Courtesy of Heritage Place, Lenoir Community College.)

Two

FRIENDLY FACES

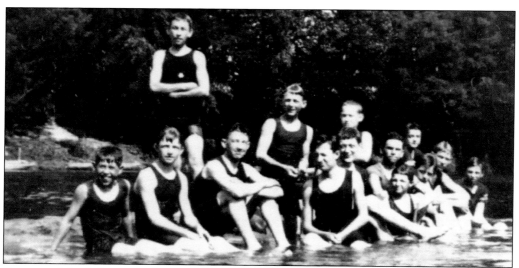

Because of the holes in the bottom of the Neuse River, there was a law prohibiting swimming in it. Therefore, when these young boys were caught swimming on a nice summer day, they were arrested and brought before Walter D. LaRoque Jr., Kinston's 40th mayor, who served from 1908 to 1912. He sentenced the boys to work off a $1 fine with their mothers. From left to right the boys are J.B. Cummings, Robert I. Dunn, Will Lewis, Melly Lewis, Percy West, Felix Harvey, Robert Rouse, Donnie Lewis, Thornton Hood, William Faulkner, two unidentified boys, Ben Patrick, and one unidentified boy. (Courtesy of Marianna Lewis.)

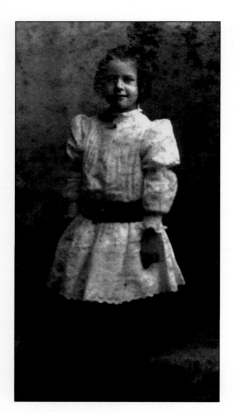

This seven-year-old girl, Mildred Lee Hill, shows off her beautiful dress in a portrait taken in the early 1900s. (Courtesy of Sue Rouse.)

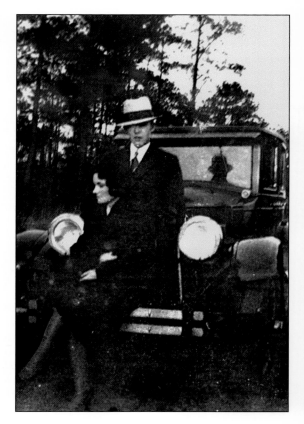

While resting on their car in the 1930s, something upset Ada Pearl Johnson Williams so much that her husband, Park, does not seem to be able to console her. (Courtesy of Judy Carey.)

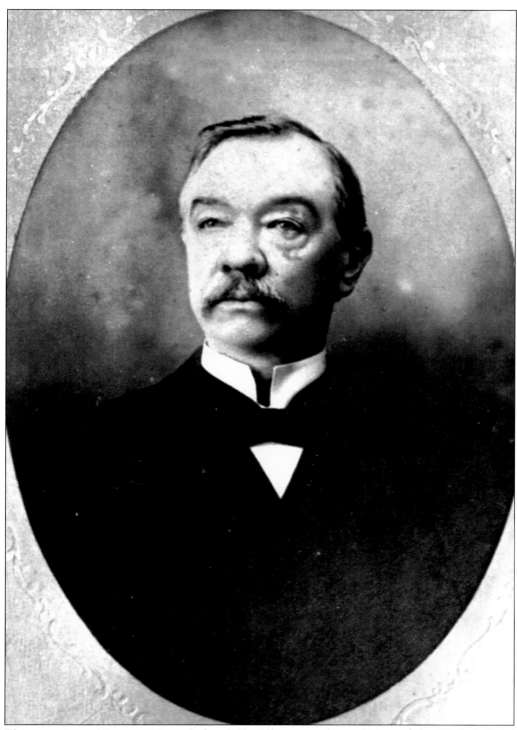

This prominent Kinston citizen, Judge O.H. Allen, served as solicitor of the Sixth Judicial District in the early 1900s. (Courtesy of Heritage Place, Lenoir Community College.)

While standing in front of a window in her home, this young girl, Ada Pearl Johnson Williams, poses for a picture. (Courtesy of Judy Carey.)

Charles W. Forlaw served as city editor to the *Kinston Daily Free Press* in the early 1900s. (Courtesy of Heritage Place, Lenoir Community College.)

Capt. Jesse W. Grainger's son-in-law, Dr. Daniel T. Edwards, served as editor of the *Kinston Daily Free Press*. Captain Grainger bought the publication in 1903. (Courtesy of Heritage Place, Lenoir Community College.)

Lemuel Harvey was born in 1845 and opened a general stock of goods business in 1869. Harvey School in Kinston was named after Lemuel Harvey for his work in public education. (Courtesy of Heritage Place, Lenoir Community College.)

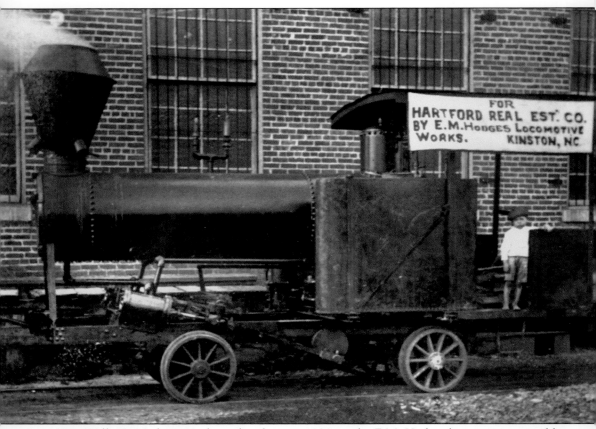

Jesse Willis P. Hodges, age five, plays here in 1908 on the E.M. Hodges locomotive owned by his father. (Courtesy of Heritage Place, Lenoir Community College.)

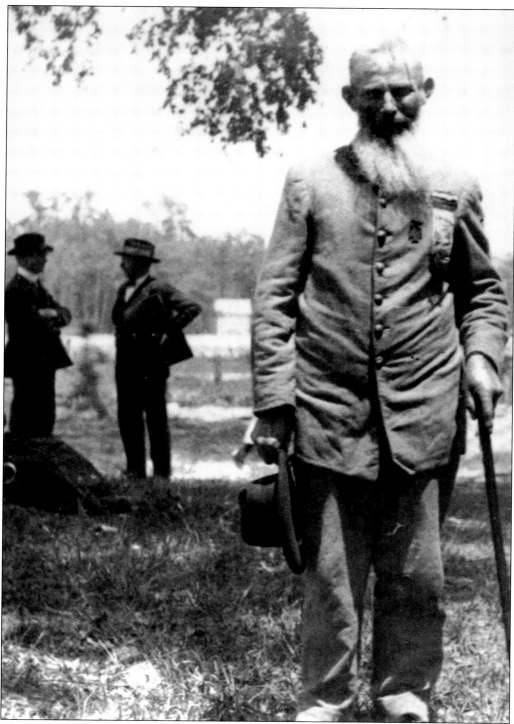

This Confederate soldier, dressed in his uniform, attended a ceremony to place a memorial at one of the battlefields in Kinston. (Courtesy of Heritage Place, Lenoir Community College.)

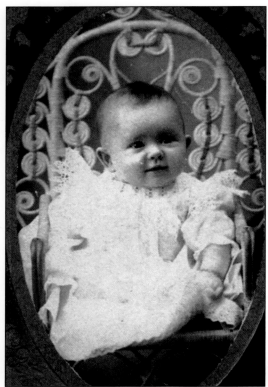

Mildred Lee Hill's first picture turned out to be a good one. She seems to be a happy baby in her beautiful lace dress. (Courtesy of Sue Rouse.)

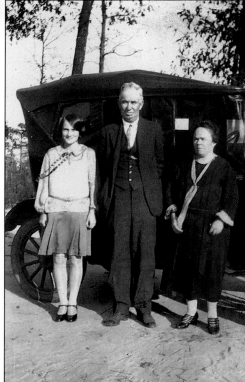

Wearing their Sunday best in 1926, Sydney Johnson, Anna Johnson, and Ada Pearl Johnson stop for a quick photo in front of the family's automobile. (Courtesy of Judy Carey.)

Joe Butler Banks, pictured with his wife, Mariah Mercer, fought in the Civil War. (Courtesy of Heritage Place, Lenoir Community College.)

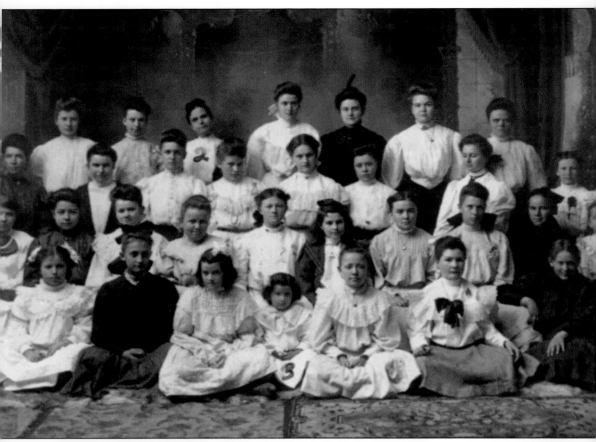

The music classes of Ms. Bettie Bray take a break from their lessons for a group picture in 1905. (Courtesy of Heritage Place, Lenoir Community College.)

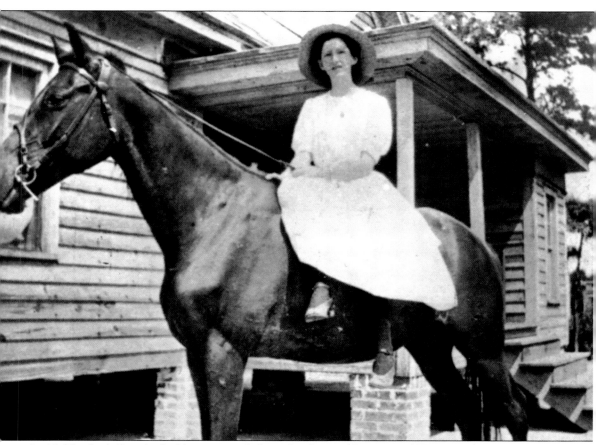

At 16, Elizabeth Bray looks like a proper lady on her horse. (Courtesy of Heritage Place, Lenoir Community College.)

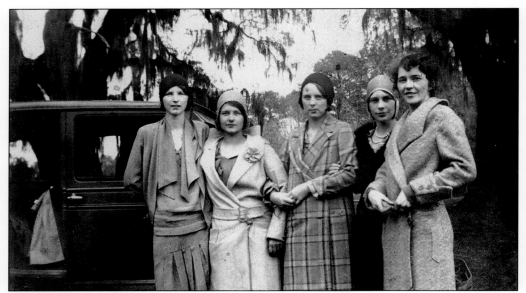

Before an outing, these women stop to take a picture on this cold day. They mark the style of the 1920s with their coats, hats, and dresses. (Courtesy of Judy Carey.)

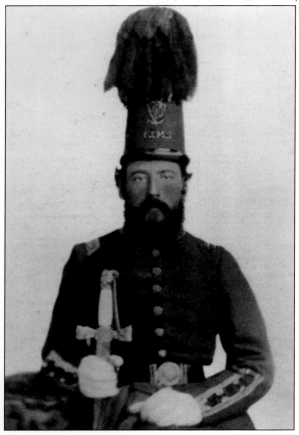

Dr. Richard Henry Lewis served Kinston as an educator for most of his life. He is pictured here in a distinguished and ornate military uniform. (Courtesy of Heritage Place, Lenoir Community College.)

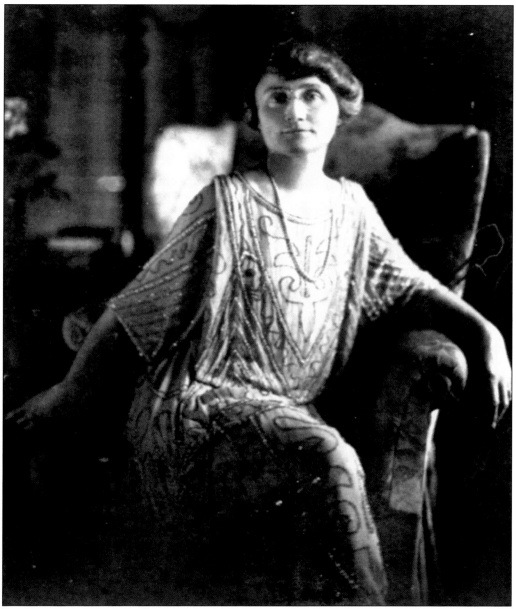

Beads and pearls decorate this woman's elaborate dress as she strikes a pose for the camera in the early 1900s. (Courtesy of Heritage Place, Lenoir Community College.)

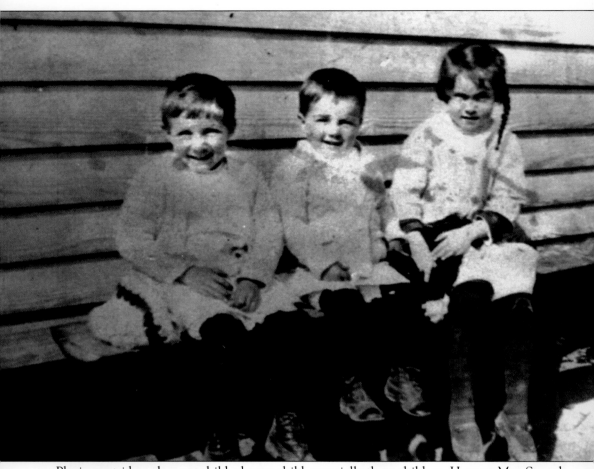

Playing outside makes any child a happy child, especially these children, Herman Max Stroud, Percy Travis Stroud, and Rosebud Waller in 1915. (Courtesy of Heritage Place, Lenoir Community College.)

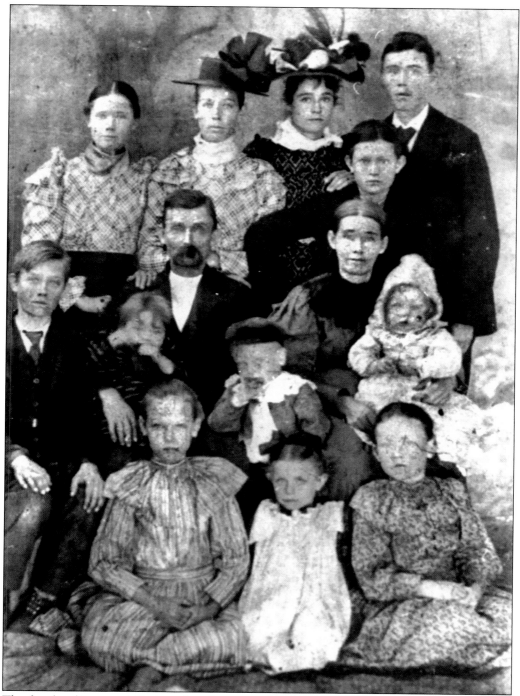

The family of Jerry and Greinza Ann Jarman gather for a family portrait in their nicest attire about 1900. (Courtesy of Heritage Place, Lenoir Community College.)

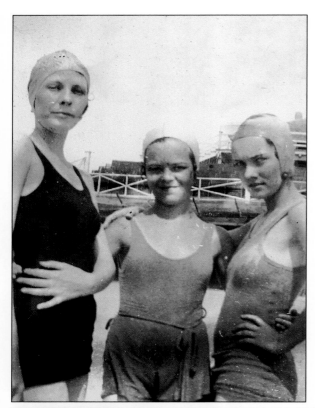

From left to right, Ada Pearl Johnson Williams, Tootsie Dunbar, and an unidentified girl enjoy an afternoon swim on a nice summer day in the 1930s in Kinston. (Courtesy of Judy Carey.)

Dr. Daniel Thomas Edwards is pictured in his study. After being educated at Trinity College (now Duke University) and the University of North Carolina Law School, and after receiving his Doctor of Philosophy from New York University, Dr. Edwards returned to Kinston to be the editor of the *Kinston Daily Free Press*, owned by his father-in-law, Jesse W. Grainger. When he returned to Kinston, he served the community extensively in business, education, religious, and civic roles. (Courtesy of Heritage Place, Lenoir Community College.)

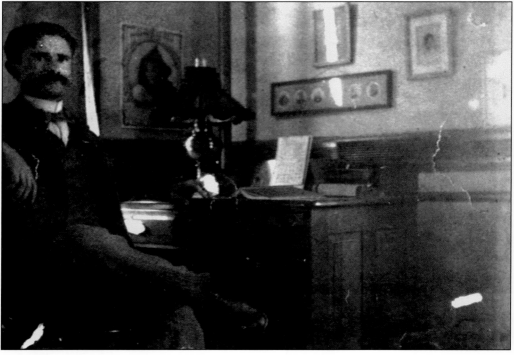

Richard W. King was born in 1818 and served as sheriff of Lenoir County. He also served in the state senate in 1870 and 1880, and he attended the Constitutional Convention in 1866–1868. Richard King was the great-great grandfather of Wilber F. King Jr. (Courtesy of Wilber F. King Jr.)

In the early 1950s, Lawrence and Lois King entered into the King business. They were in charge of the grocery operation that had been added to the store owned by Wilber King Sr. and Victor King, Lawrence's brothers. When the business was expanded and remodeled it was known as King Brother's Barbecue and Supermarket. It was renamed in the 1970s as King's Restaurant and King's Red and White. (Courtesy of William Wilder.)

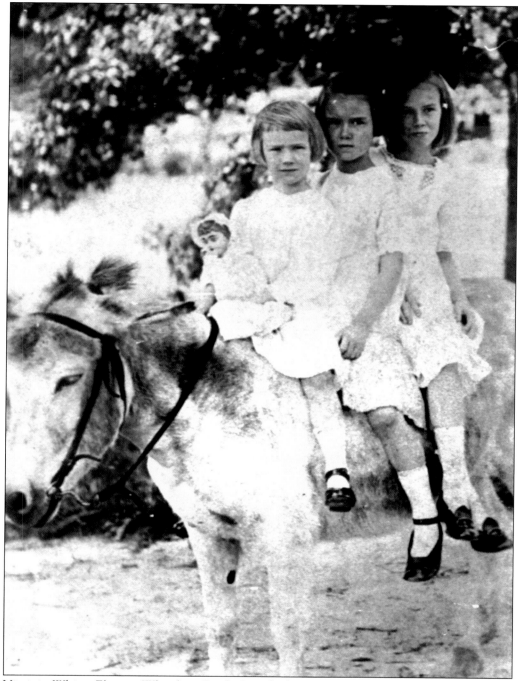

Virginia White, Eleanor Whitaker, Sarah Crawford, and their doll enjoy a ride on a horse. (Courtesy of Heritage Place, Lenoir Community College.)

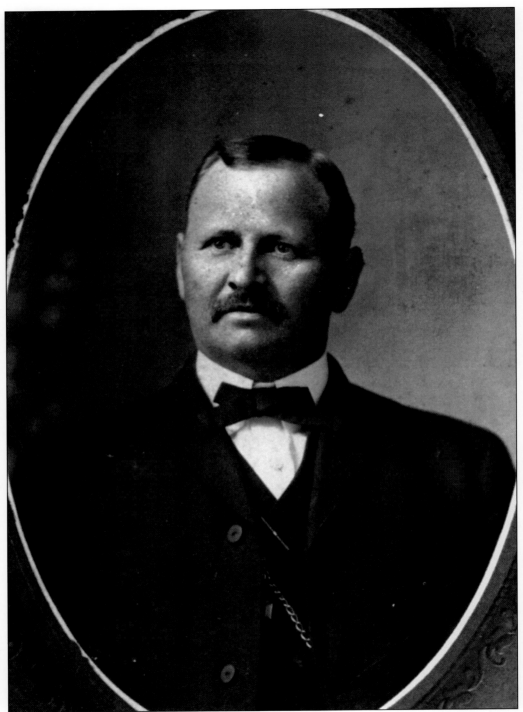

G.W. Sumrell owned Sumrell and McCay Wholesale, which carried a complete line of the usual first-class, up-to-date wholesale items such as meat, flour, coffee, canned goods, tobacco, and molasses. (Courtesy of Heritage Place, Lenoir Community College.)

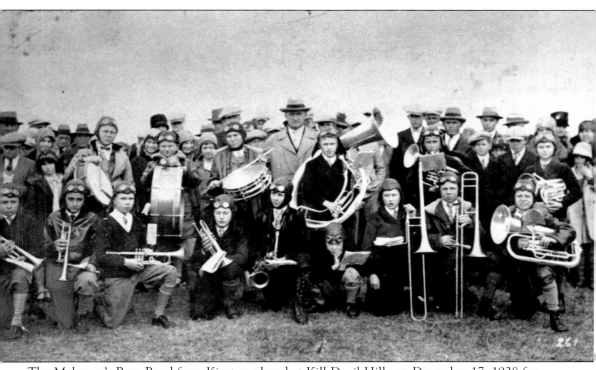

The Mehegan's Boys Band from Kinston played at Kill Devil Hills on December 17, 1928 for the unveiling of the monument that commemorated the 25th anniversary of the first successful flight of an airplane. Orville Wright attended as well. (Courtesy of Heritage Place, Lenoir Community College.)

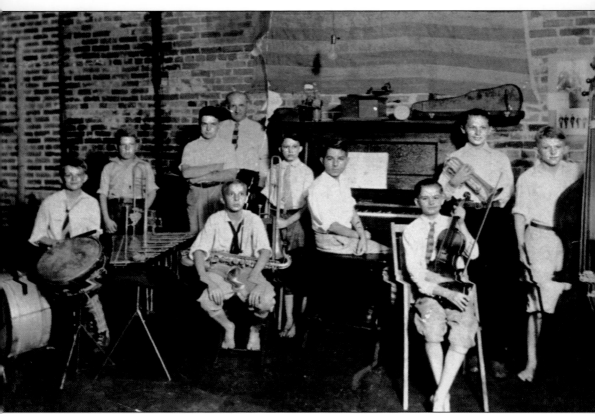

These boys belonged to the Mehegan's Boys Orchestra in the 1920s. They are, from left to right, (front row) Bill McDevitt, Tony Carey, and Willie Dudley; (back row) F.A. Gardner Jr., Joseph Harrison, Mr. Mehegan, Sam Stapleford, Paul Taylor, Harvey Caton, and Johnnie McAvery. (Courtesy of Heritage Place, Lenoir Community College.)

Someone snaps a picture of Ada Pearl Johnson Williams striking a playful pose in the 1930s. (Courtesy of Judy Carey.)

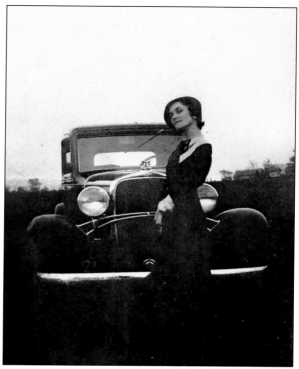

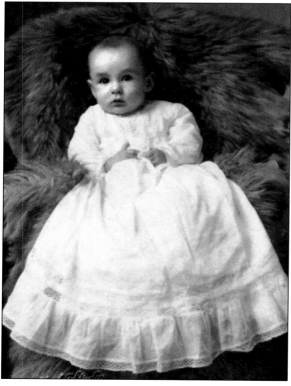

In Frank Alex Rouse's baby portrait, he wears a beautiful, long, white dress with ribbon and lace. (Courtesy of Sue Rouse.)

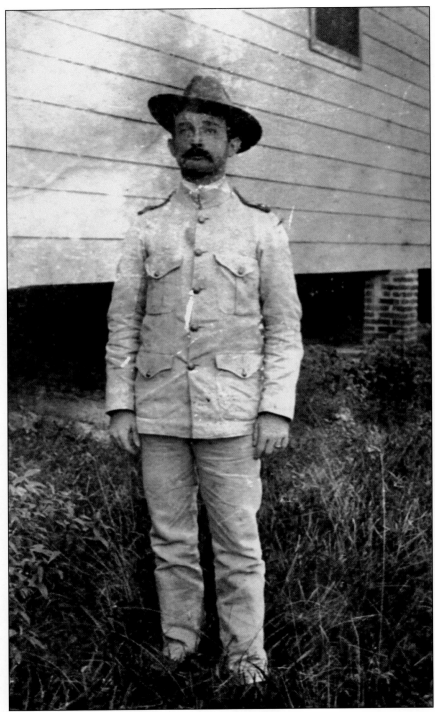

This proud soldier dons his uniform as he stands for a picture. Kinston citizens have continuously given their lives and service to their country when called to duty. (Courtesy of Heritage Place, Lenoir Community College.)

Anna Oliver McDaniel's parents owned and operated the Kinston Dairy. They provided Kinston with fine dairy products for many years. (Courtesy of Heritage Place, Lenoir Community College.)

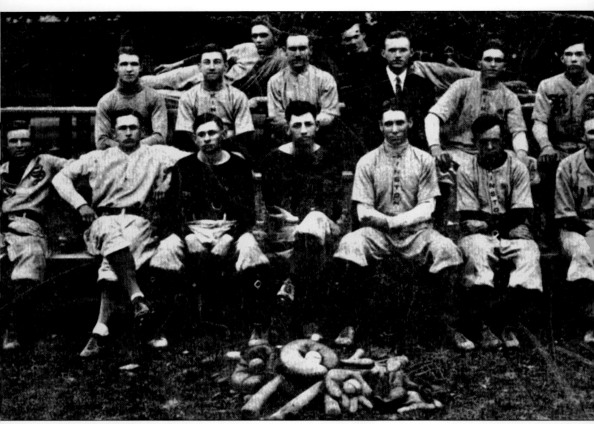

Kinston has always loved baseball. This Kinston baseball team picture is from the early 1900s.
(Courtesy of Frances Lipscomb.)

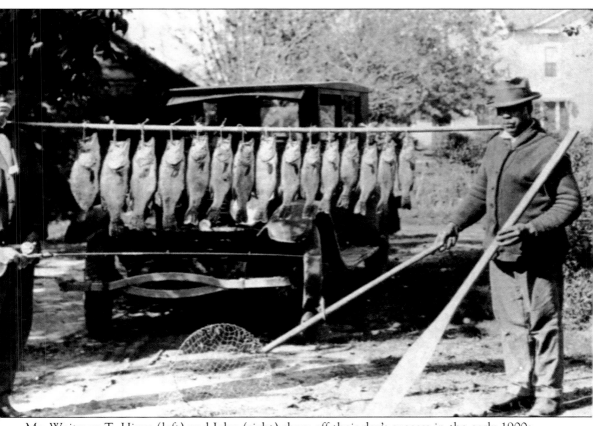

Mr. Waitman T. Hines (left) and John (right) show off their day's success in the early 1900s. (Courtesy of Heritage Place, Lenoir Community College.)

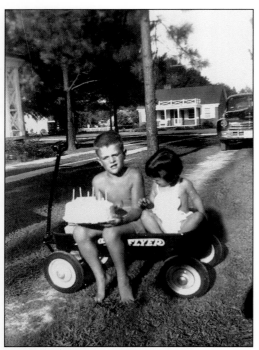

Douglas Williams and Judy Williams Carey celebrate Douglas's birthday with a cake and a ride in the wagon in the early 1950s. (Courtesy of Judy Carey.)

On a nice Sunday afternoon in the 1950s, David and Sallie Rouse Williams enjoy each other's company and their pleasant surroundings. (Courtesy of Judy Carey.)

Three

HISTORIC HOMES

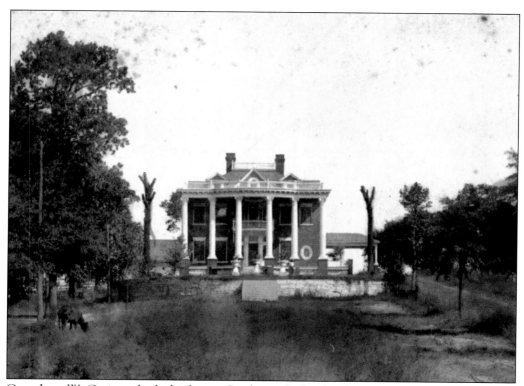

Capt. Jesse W. Grainger built this house, Sarahurst, for his daughter, Capitola Coward Grainger in the early 1900s. (Courtesy of Heritage Place, Lenoir Community College.)

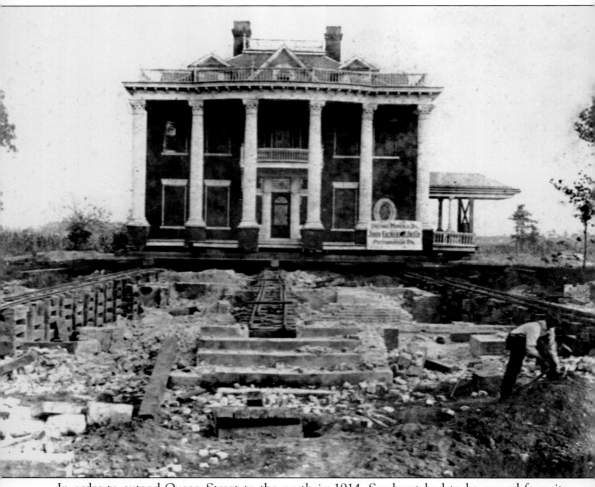

In order to extend Queen Street to the north in 1914, Sarahurst had to be moved from its original position facing Queen Street. It was moved back and west, where it now stands. According to Mrs. John W. Montgomery in an article for the *Kinston Free Press*, not a drop of water was spilled from a glass on the mantle when the house was moved. The moving process is underway in this picture. (Courtesy of Heritage Place, Lenoir Community College.)

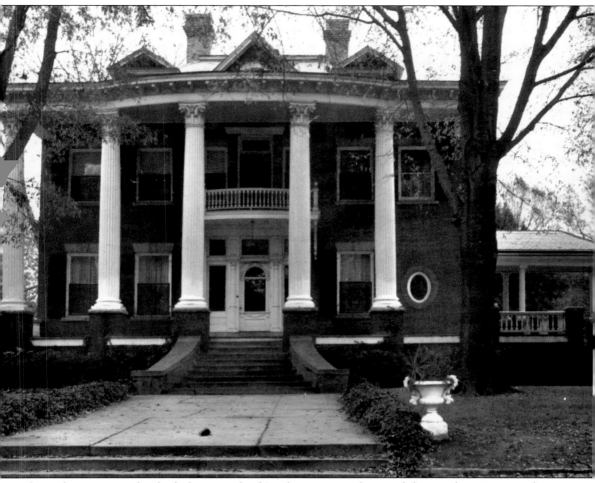

Once the move was finished, the grounds of Sarahurst were redone and the new location served the home well. Queen Street was extended north, and the town continued to prosper from the growth it was experiencing. (Courtesy of Heritage Place, Lenoir Community College.)

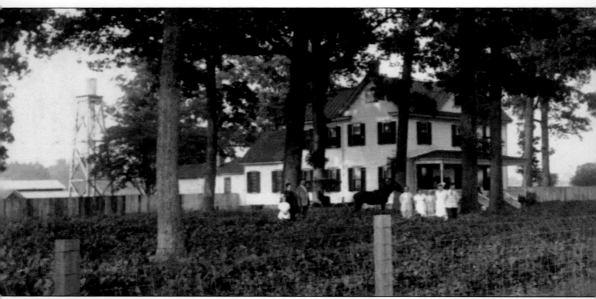

Caswell Center opened the Stroud House (Carrie Williams Schweikert Home) in 1911. (Courtesy of the North Carolina Collection, University of North Carolina at Chapel Hill.)

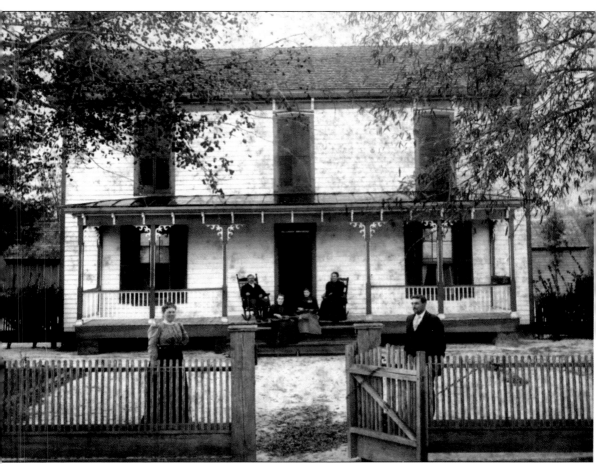

The home of William Patrick and Mary Grimsley Jones used to be on a tract of land through which Carey Road now goes. The people on the porch are, from left to right, Podie J. Hines and Cora J. Crawford, and the people standing at the fence are Annis and Jons Jones. (Courtesy of Heritage Place, Lenoir Community College.)

This historic home used to be where Dr. R.H. Lewis operated his last school in Kinston. Located on East King Street, it was occupied by Dr. Lewis and his students from 1877 to 1902. (Courtesy of Sue Rouse.)

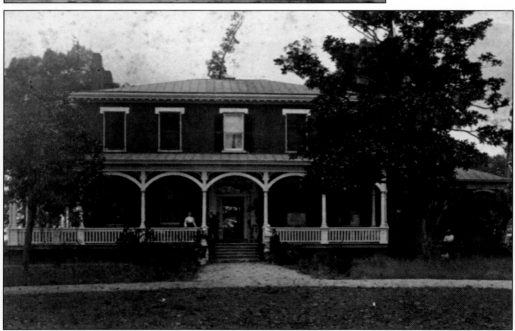

Vernon Heights was the previous home of the Washington Family of Kinston. Capt. Jesse Grainger also owned this property. However, when Harvey held ownership, he had the house pictured here torn down and another, Vernon Hall, erected. (Courtesy of Heritage Place, Lenoir Community College.)

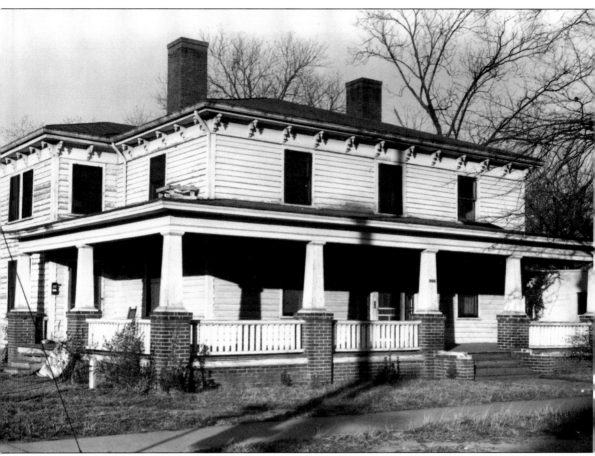

Dr. Faulkner, the owner of the Faulkner Home on the northeast corner of King and McLewean Streets, practiced dentistry in a little house on the left. (Courtesy of Heritage Place, Lenoir Community College.)

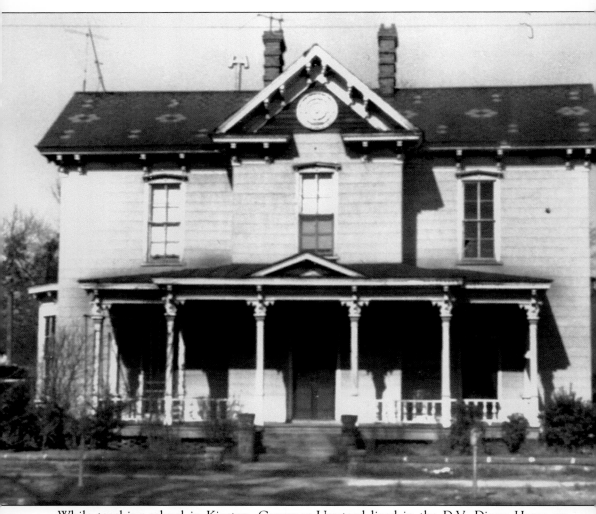

While teaching school in Kinston, Governor Umstead lived in the D.V. Dixon Home on the northwest corner of Blount and McLewean Streets. (Courtesy of Heritage Place, Lenoir Community College.)

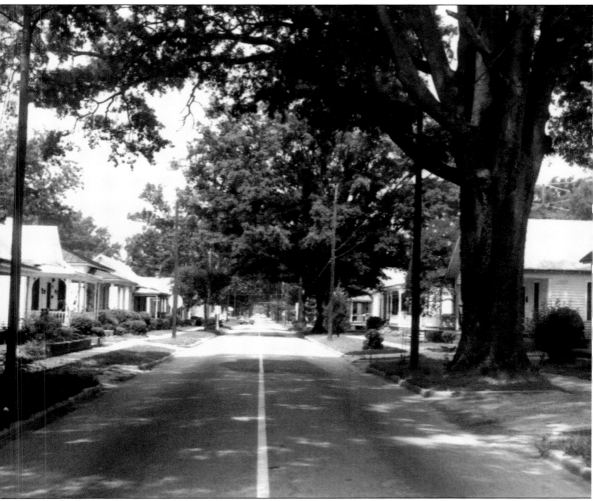

Looking west down Vernon Avenue, Kinston homes during the summer of 1967 can be seen. This picture was taken from the Atlantic Coast Line's railroad crossing that was also on Vernon Avenue at the time. Shortly after this picture, the city widened the street. (Courtesy of Heritage Place, Lenoir Community College.)

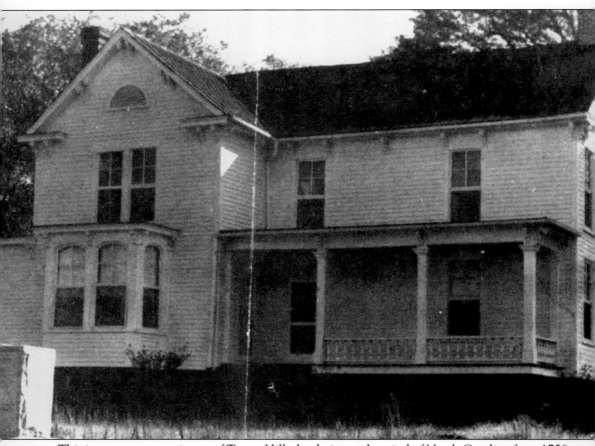

This is a more recent picture of Tower Hill, the designated capitol of North Carolina from 1758 to 1762. (Courtesy of Heritage Place, Lenoir Community College.)

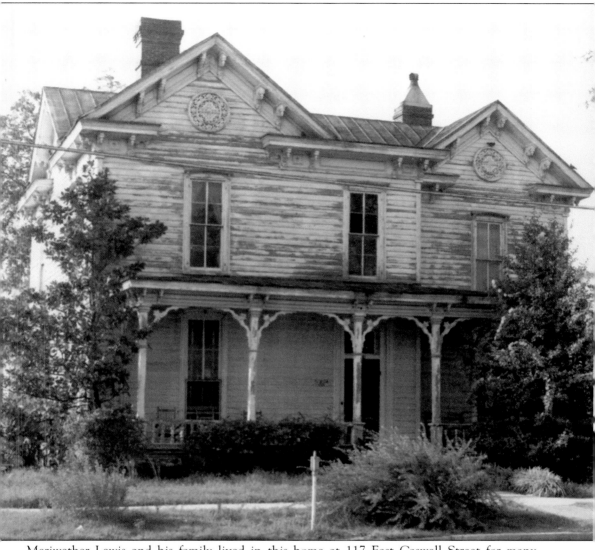

Meriwether Lewis and his family lived in this home at 117 East Caswell Street for many years. Lewis was a prominent land surveyor for Kinston. (Courtesy of Heritage Place, Lenoir Community College.)

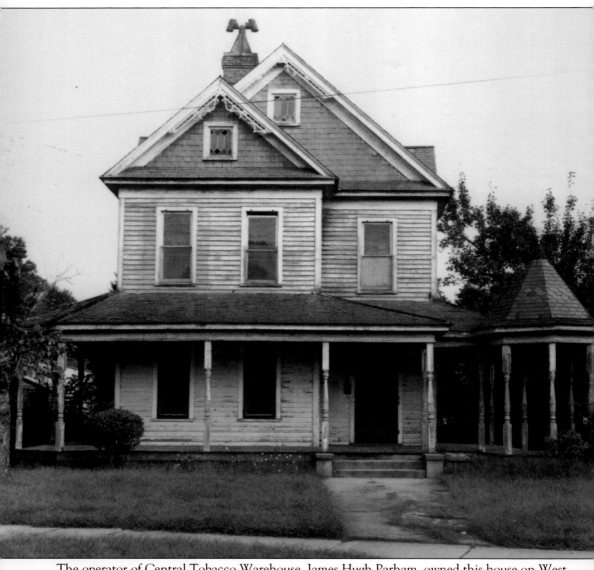

The operator of Central Tobacco Warehouse, James Hugh Parham, owned this house on West Peyton Avenue. (Courtesy of Heritage Place, Lenoir Community College.)

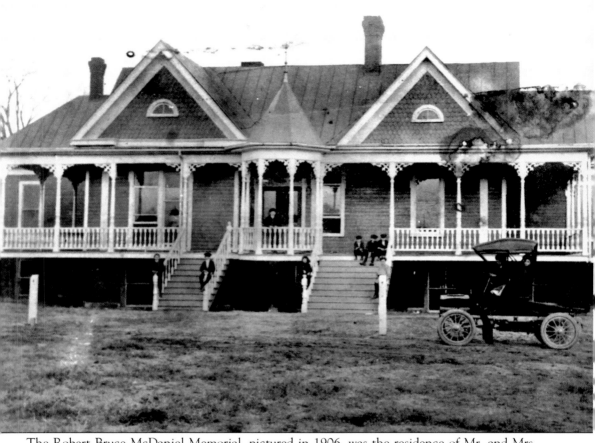

The Robert Bruce McDaniel Memorial, pictured in 1906, was the residence of Mr. and Mrs. James A. McDaniel. They sold their residence to Dr. James M. Parrott and Dr. W. Thomas Parrott at 801 East Gordon Street to be used for a hospital. The hospital had accommodations for 35 patients, and it was named after the son of Mr. and Mrs. McDaniel who died the year before. (Courtesy of Heritage Place, Lenoir Community College.)

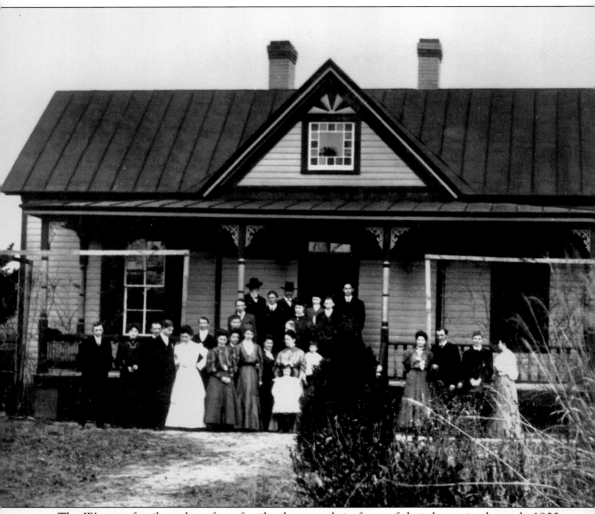

The Wooten family gathers for a family photograph in front of their home in the early 1900s. (Courtesy of Heritage Place, Lenoir Community College.)

Four

DOWNTOWN

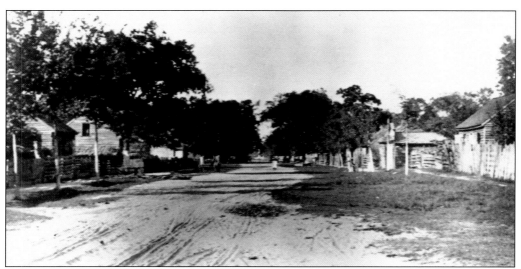

Once the Civil War was over, Kinston could begin to move forward. During a period of rapid growth and development, Kinston established itself as the town that it exists as today. This picture of Main Street in 1884 shows the beginnings of this period. Houses with fences line the street, and the road contains many horse and carriage tracks that show that traffic was beginning to accumulate in the area. (Courtesy of the North Carolina Department of Archives and History.)

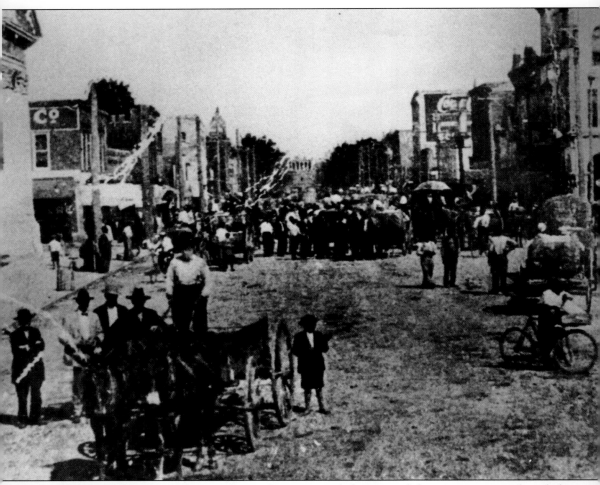

Citizens gather downtown on Queen Street around the turn of the century to tend to daily business matters. (Courtesy of Heritage Place, Lenoir Community College.)

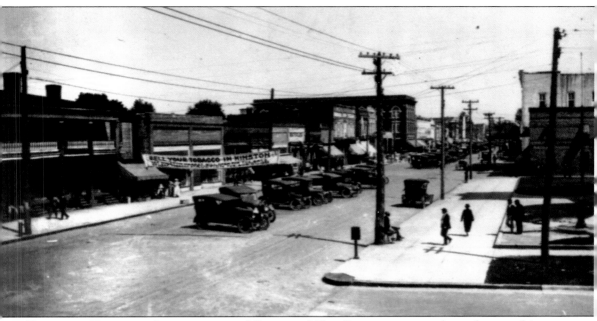

Downtown Kinston at the intersection of Queen and King Streets was a very busy place on this hot day in August 1922. The tobacco market would open the following week and the farmers and warehouse owners were getting ready for the auction. Evidence of progress can be seen in the telephone poles and new cars in the street. (Courtesy of the North Carolina Collection, University of North Carolina at Chapel Hill.)

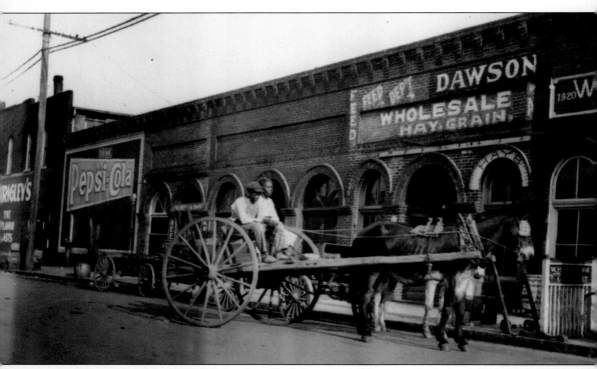

This street scene from 1922 shows that all of the carts and carriages had not yet been replaced by automobiles. These Kinston citizens are probably waiting for products from this store. (Courtesy of the North Carolina Collection, University of North Carolina at Chapel Hill.)

Maplewood Cemetery on King Street is the burial place of many of Kinston's prominent residents from the past such as Richard W. King, who died in 1883. (Courtesy of Heritage Place, Lenoir Community College.)

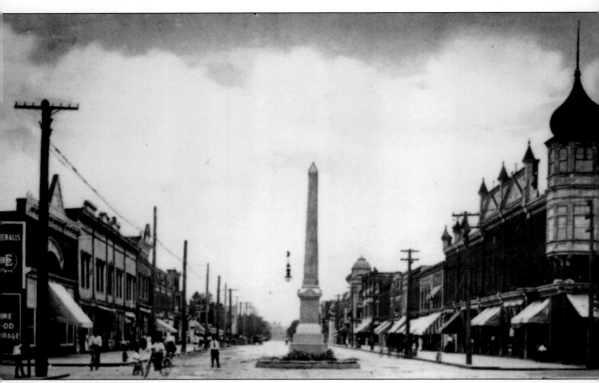

The Caswell Monument was 16 feet high. It stood at the center of Queen and Caswell Streets from 1881 to 1934. Because drivers kept running into the monument, it had to be moved to a better location. (Courtesy of Heritage Place, Lenoir Community College.)

King Street reveals much progress since the time this picture was taken. Developments in the roads, sidewalks, and houses are easily discernible. (Courtesy of Heritage Place, Lenoir Community College.)

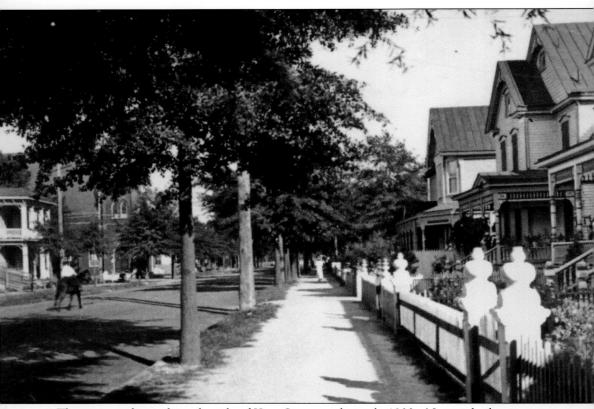

This picture shows the right side of King Street in the early 1900s. Notice the horse roaming the street! (Courtesy of Heritage Place, Lenoir Community College.)

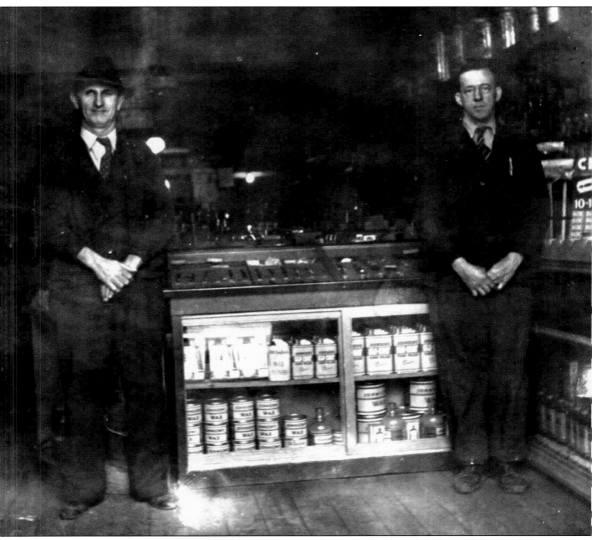

The Grady-Hartsfield Store stood on Queen Street. Bob Grady (left) and Calvin Willis (right) pose in the store in the 1930s. (Courtesy of Heritage Place, Lenoir Community College.)

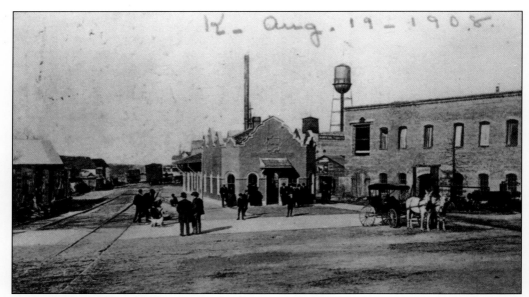

The Atlantic and North Carolina Railroad Station, pictured in 1908, was directed by Lemuel Harvey for 25 years. (Courtesy of Heritage Place, Lenoir Community College.)

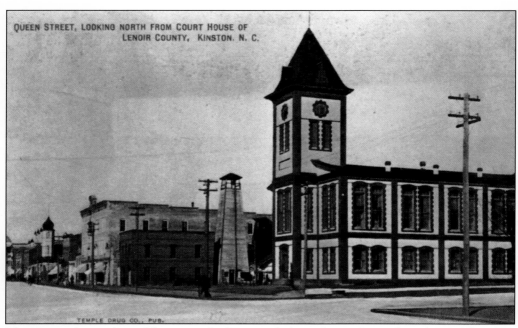

This postcard was taken of downtown looking north down Queen Street from the courthouse in the early 1900s. (Courtesy of Heritage Place, Lenoir Community.)

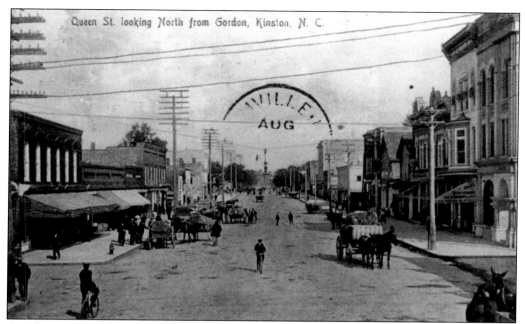

Another postcard from 1906 shows Queen Street looking north from Gordon Street. A busy afternoon downtown could be fun for the whole family. (Courtesy of Heritage Place, Lenoir Community College.)

Automobiles and newer buildings show the progress and growth Kinston experienced in the 1930s. (Courtesy of Heritage Place, Lenoir Community College.)

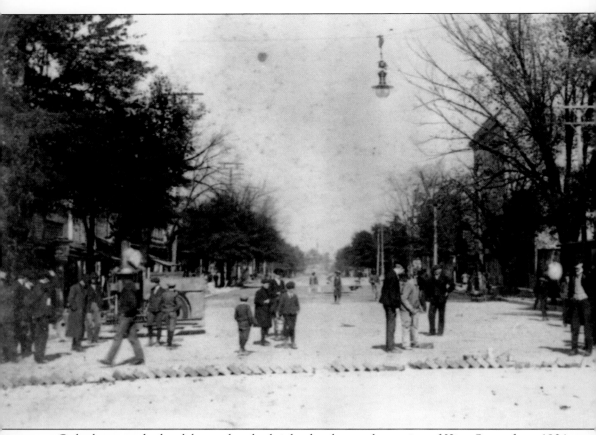

Onlookers watched as laborers lay the bricks that began the paving of King Street from 1904 to 1906. This project was part of a plan the town voted for in 1903 to make new progress in Kinston. (Courtesy of Heritage Place, Lenoir Community College.)

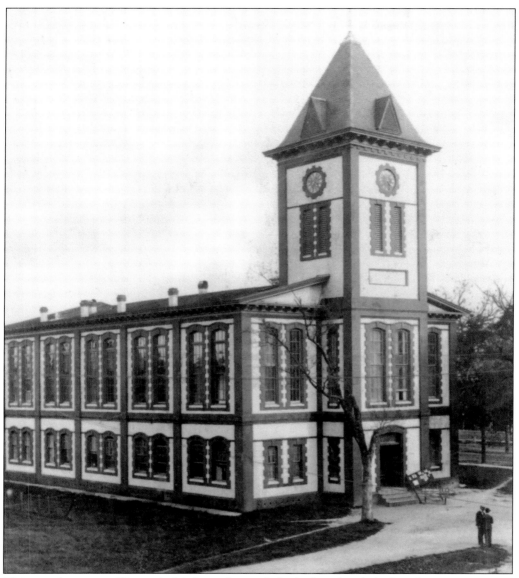

This courthouse was Kinston's third courthouse. It had a four-faced clock and was in operation from 1880 to 1940. The previous courthouse burned down in the Fire of 1878, which was caused by the clerk of court. (Courtesy of Heritage Place, Lenoir Community College.)

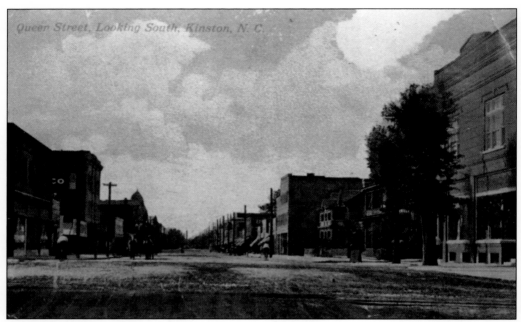

This picture from the early 1900s looks south down Queen Street. (Courtesy of Heritage Place, Lenoir Community College.)

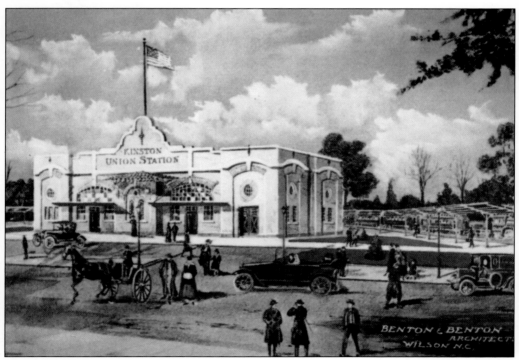

The depiction of cars and carriages in front of a drawing of Kinston Union Station mark the period of transition between the past era of horse and buggy and the new exciting era of planes, trains, and automobiles. (Courtesy of Heritage Place, Lenoir Community College.)

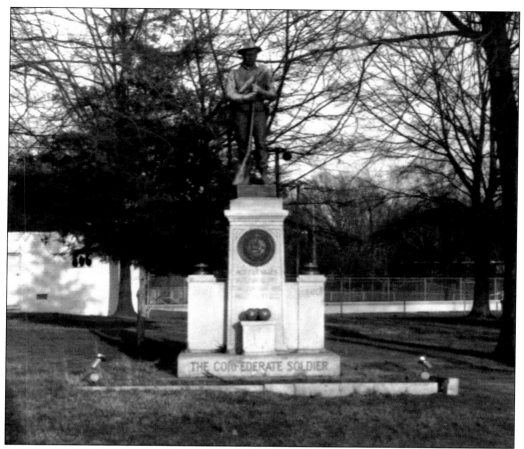

On December 1, 1881, a publication of Kinston asked for donations towards a Confederate monument. An unknown gentleman offered to contribute $10 believing that there were other citizens as noble and generous. The publication concluded to appeal to all those who sympathize with the movement and to all who desire to keep green the memory of those who yielded their lives at their country's call. The monument was erected on the Southeast corner of Queen and Highland Avenues and this picture was taken March 10, 1965. (Courtesy of Heritage Place, Lenoir Community College.)

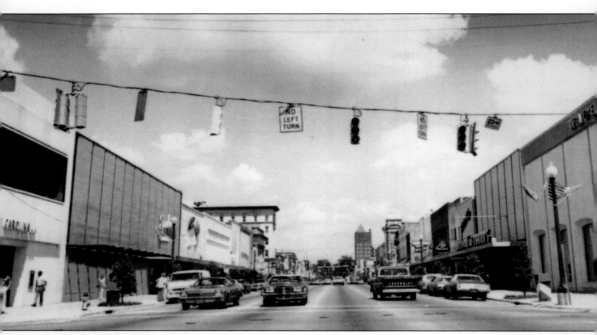

By the mid-20th century, downtown Kinston looked like a whole new place. A variety of cars now sped down Queen Street, traffic lights had been installed, and the town had grown immensely. (Courtesy of Heritage Place, Lenoir Community College.)

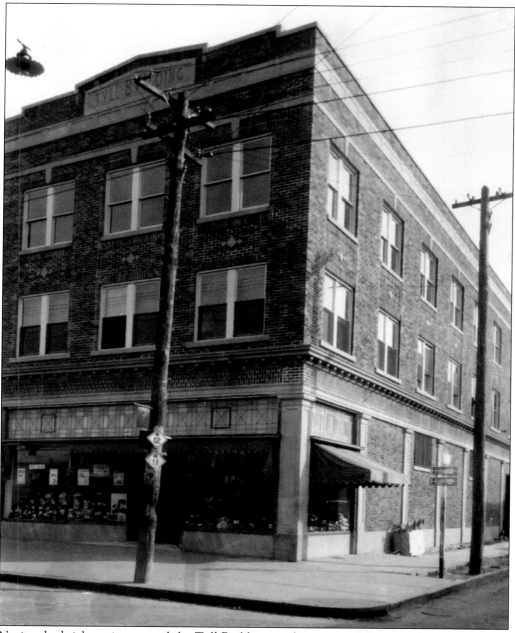

Notice the brick paving around the Tull Building on the corner of Queen and Caswell Streets around 1906. (Courtesy of Frances Lipscomb.)

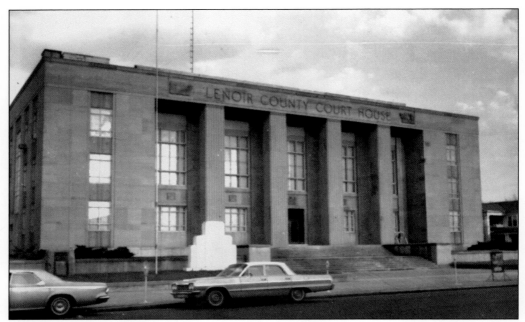

When the old courthouse was torn down in 1940, this courthouse was built to serve the needs of the growing community. (Courtesy of Heritage Place, Lenoir Community College.)

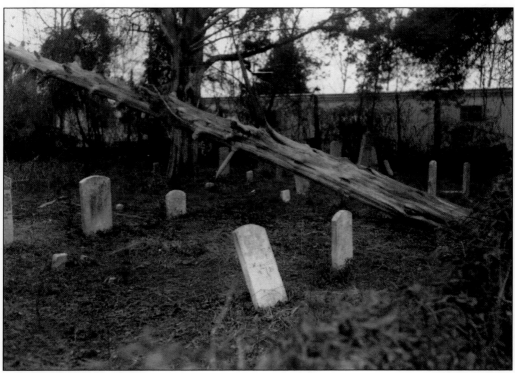

This old cemetery provided some of Kinston's residents with a place of final rest in the soil they loved. (Courtesy of Heritage Place, Lenoir Community College.)

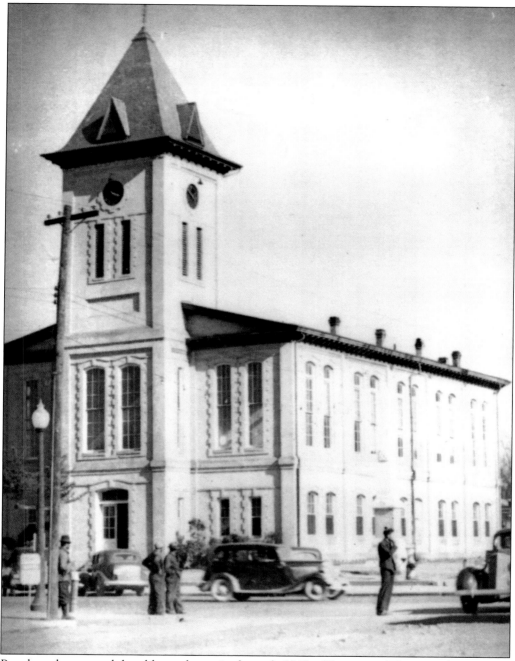

People gather around the old courthouse in the early 1900s. (Courtesy of Heritage Place, Lenoir Community College.)

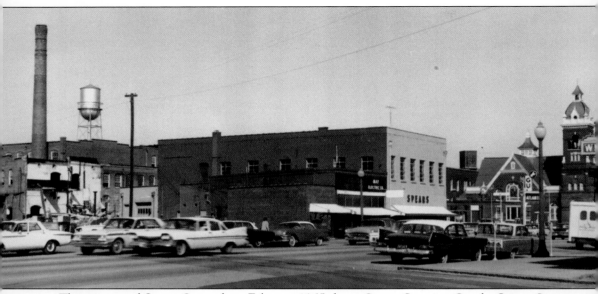

This picture of Queen Street from February 1965 shows Spears Sporting Goods, Queen Street Methodist Church, and many other downtown landmarks. (Courtesy of Heritage Place, Lenoir Community College.)

Five

CHURCHES AND SCHOOLS

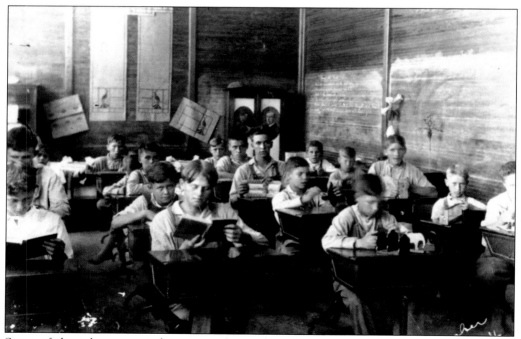

Some of these boys are studying intently on the subject at hand, but some of their fellow classmates are having trouble staying focused in this classroom in 1924. (Courtesy of the North Carolina Collection, the University of North Carolina at Chapel Hill.)

Dr. Richard Henry Lewis served as a doctor in the Civil War but gave up practicing medicine to teach. In 1877, Dr. Lewis and C.W. Howard opened the Kinston Collegiate Institute. Lewis also opened Kinston College in 1882. Lewis School was named after this devoted educator. (Courtesy of Marianna Lewis.)

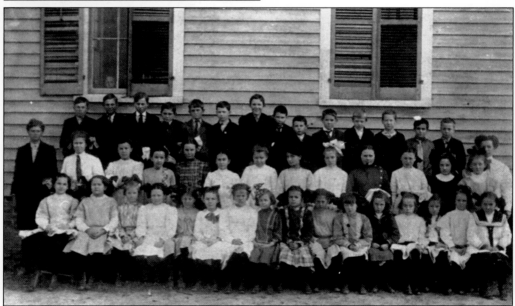

This fourth grade class had the honor of Miss Scotia Hobgood, one of Kinston's beloved educators, as their teacher. The students attended the first three grades in Lewis School. Some of the teachers at this time were Miss Lucy Brooks, Miss Emma Webb, Miss Sally Shaw, and Miss Ruby Tull. (Courtesy of Heritage Place, Lenoir Community College.)

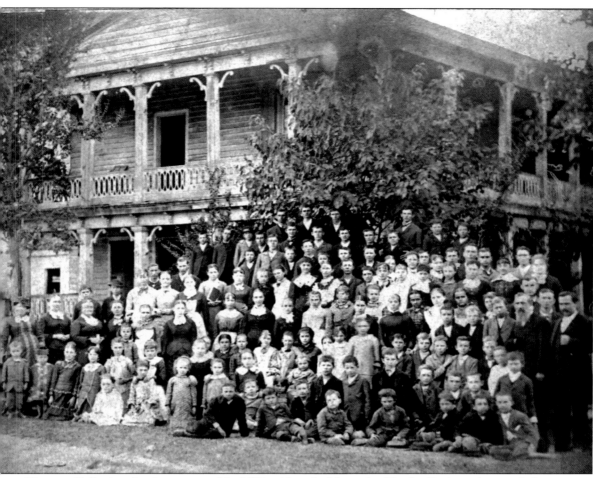

Kinston Collegiate Institute opened in 1871 with only 36 pupils. Charles B. Aycock attended this school and delivered the commencement address for this class in 1879. (Courtesy of Heritage Place, Lenoir Community College.)

John W. Tyndall established a private school, locally called Tyndall's College, in 1907. It operated until 1914. (Courtesy of Heritage Place, Lenoir Community College.)

These teachers convened to discuss education in Kinston in the late 1800s. (Courtesy of Heritage Place, Lenoir Community College.)

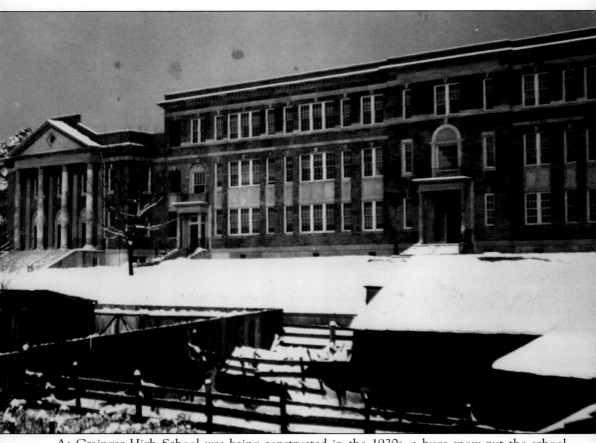

As Grainger High School was being constructed in the 1920s, a huge snow put the school under a blanket of white. Grainger High School was named for Capt. Jesse Grainger, a civic and business leader. (Courtesy of Heritage Place, Lenoir Community College.)

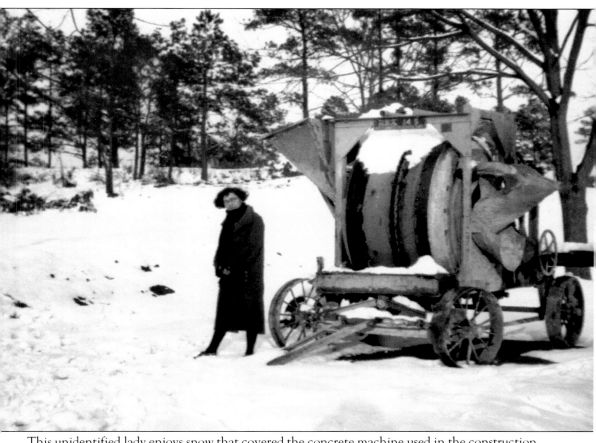

This unidentified lady enjoys snow that covered the concrete machine used in the construction of Grainger High School in 1926. (Courtesy of Heritage Place, Lenoir Community College.)

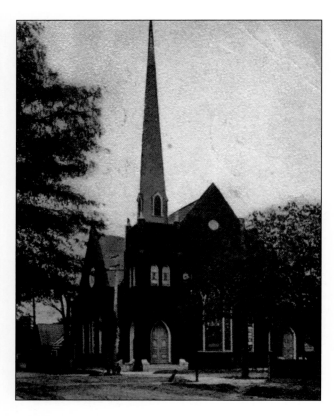

Kinston Baptist Church began in the 1770s at Southwest Creek. As its congregation grew, the church was moved to downtown Kinston where this picture was taken in 1905. (Courtesy of Sue Rouse.)

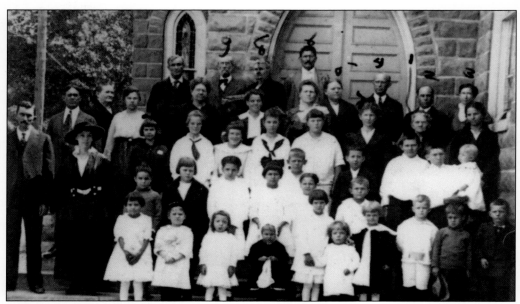

Dressed in their Sunday best, these members of The Kinston Universalist Church, built in 1913–1914, congregate for a church picture in the 1920s. (Courtesy of Heritage Place, Lenoir Community College.)

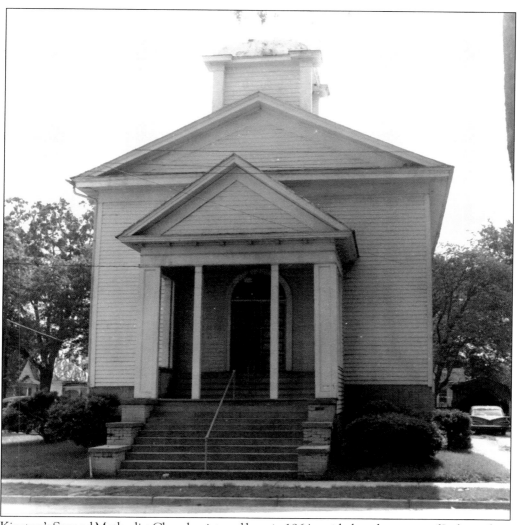

Kinston's Second Methodist Church, pictured here in 1964, resided on the corner of Independent and East Caswell Streets. During the Civil War, it was used as a hospital for Confederate Soldiers. Gen. Robert Ransom stabled his horses in the basement during 1863. It was also used as a Jewish Synagogue. (Courtesy of Heritage Place, Lenoir Community College.)

In 1906, the Whitaker Building of the Christian Science Hall provided church members with a place to gather and to worship. (Courtesy of Heritage Place, Lenoir Community College.)

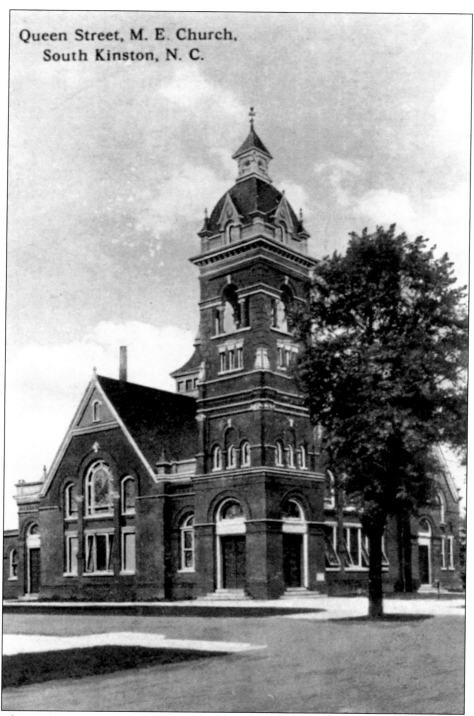

Queen Street, M. E. Church,
South Kinston, N. C.

Church members decided that the Methodist Church should be nearer to the urban center of the town. Therefore, in 1911, the new Queen Street Methodist Church was completed and dedicated. (Courtesy of Heritage Place, Lenoir Community College.)

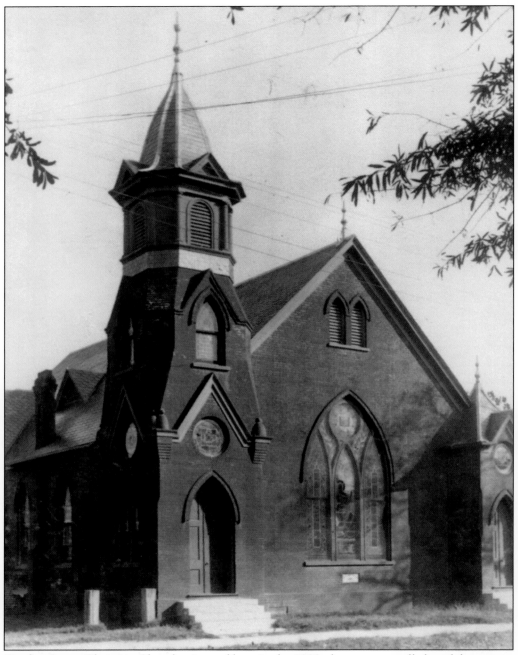

Gordon Street Christian Church, pictured here in the 1890s, began as a small chapel downtown at the intersection of Gordon and Heritage Streets. (Courtesy of Heritage Place, Lenoir Community College.)

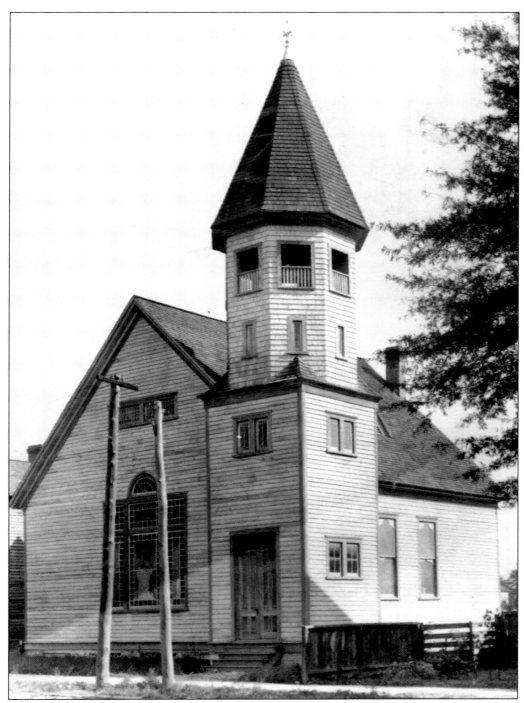

The Presbyterian Church shown in this c. 1906 photograph was built on Independent Street and was the first Presbyterian Church to thrive in Kinston. (Courtesy of Heritage Place, Lenoir Community College.)

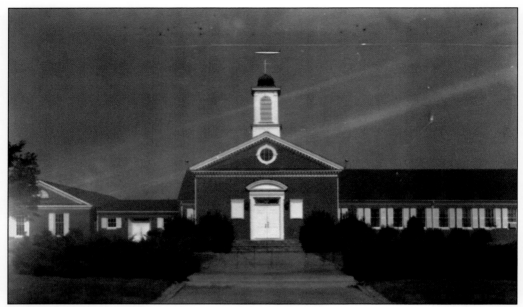

Constructed in 1956, Westminster United Methodist Church served as an extension of the Queen Street Methodist Church to meet the needs of the growing Methodist community in Kinston. (Courtesy of Heritage Place, Lenoir Community College.)

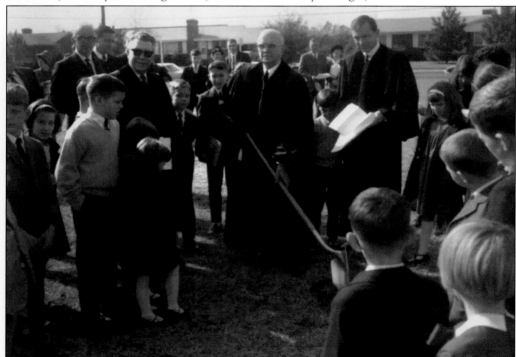

In January 1967, Westminster United Methodist Church began the construction of a two-story educational building with a groundbreaking ceremony. (Courtesy of Heritage Place, Lenoir Community College.)

Six

IMPORTANT BUSINESS

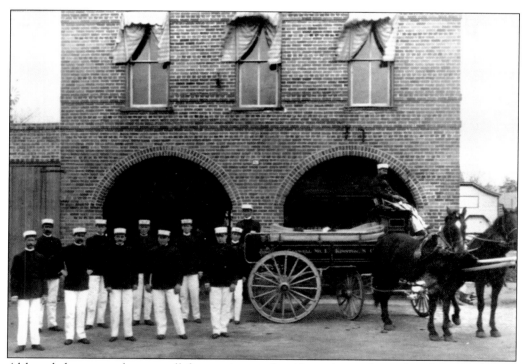

Although horses no longer pull fire engines and uniforms have changed with technological improvements, the heart of the firemen have always held the same things—courage and strength. These men stand proud as members of the Caswell Fire Company No. 1 in 1906. (Courtesy of Heritage Place, Lenoir Community College.)

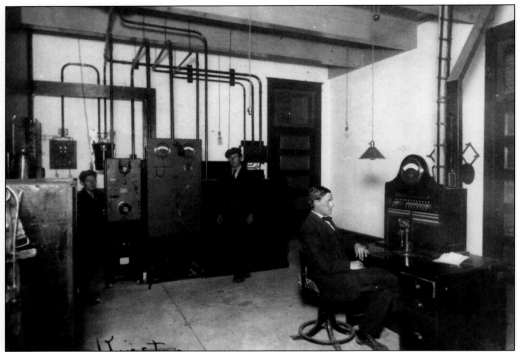

In the early 1900s, the terminal and power apparatus room for the Kinston Exchange of the Carolina Telephone and Telegraph Company was located in the Laroque Building on the corner of Queen and West Streets. (Courtesy of the North Carolina Collection, The University of North Carolina at Chapel Hill.)

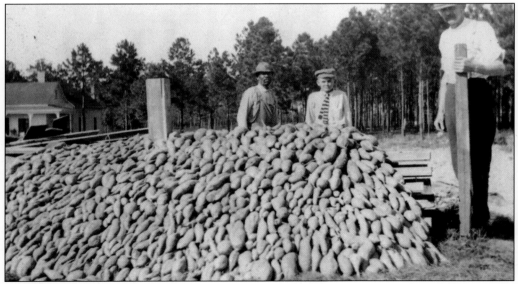

Caswell Center farmers produced many crops such as these sweet potatoes. (Courtesy of the North Carolina Collection, The University of North Carolina at Chapel Hill.)

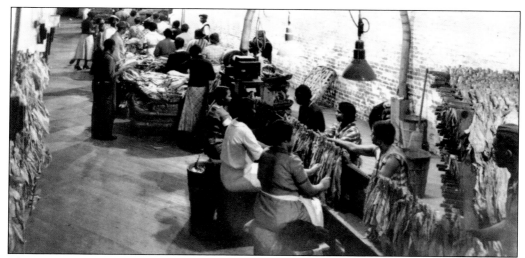

These women in 1935 work diligently in the "Hanger Room" of the tobacco stemming and redrying plant. After Capt. Jesse W. Grainger convinced farmers to plant tobacco, the crop turned into one of the most important aspects of Kinston's economic growth. (Courtesy of the North Carolina Collection, The University of North Carolina at Chapel Hill.)

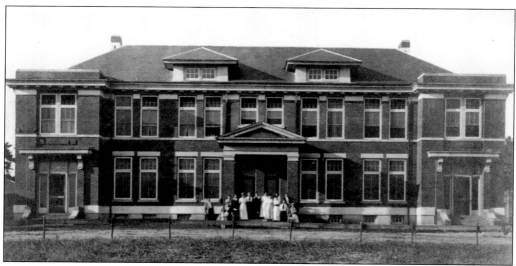

Hardy Building at Caswell Center was named after Dr. Ira Hardy, the founding father of the center. Built in 1912, it was the center building of Caswell Center. (Courtesy of the North Carolina Collection, The University of North Carolina at Chapel Hill.)

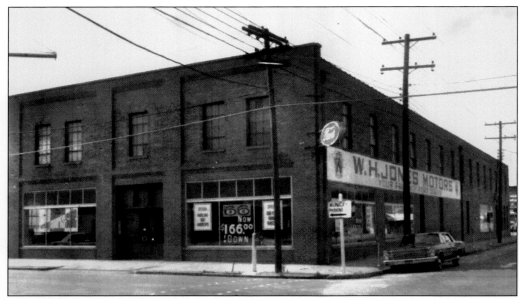

W.H. Jones Ford Agency provided Kinston's citizens with the latest Ford automobiles. (Courtesy of Heritage Place, Lenoir Community College.)

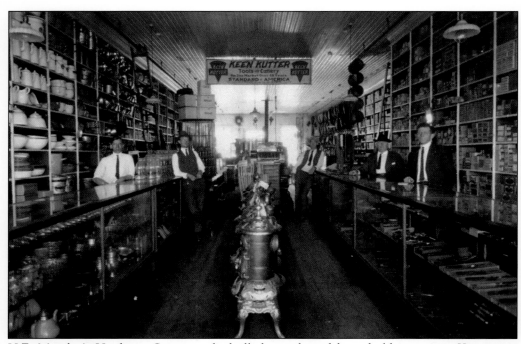

H.E. Moseley's Hardware Store supplied all the tools and household items any Kinstonian would need. The men standing in the photograph above, from left to right, are Calvin Willis, ? Britton, an unidentified man, H.E. Moseley, and H.V. Wiggins. (Courtesy of Heritage Place, Lenoir Community College.)

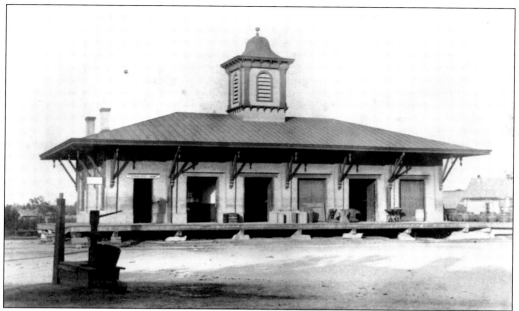

The sound of train whistles could be heard in Kinston in 1884 as they stopped at this railroad station. (Courtesy of the North Carolina Department of Archives and History.)

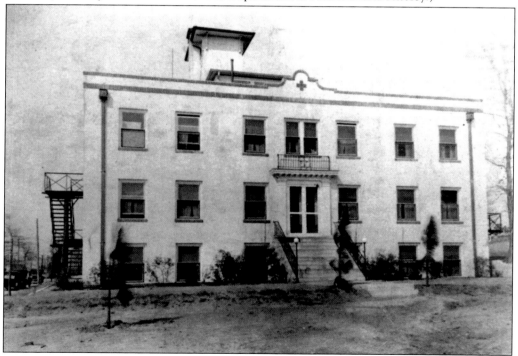

Citizens of Kinston recognized the need for a hospital to accommodate the growing population of the town in the 1920s. Memorial General Hospital was built on Rhodes Avenue and College Street. The hospital was a memorial to the citizens that served in World War I. (Courtesy of Heritage Place, Lenoir Community College.)

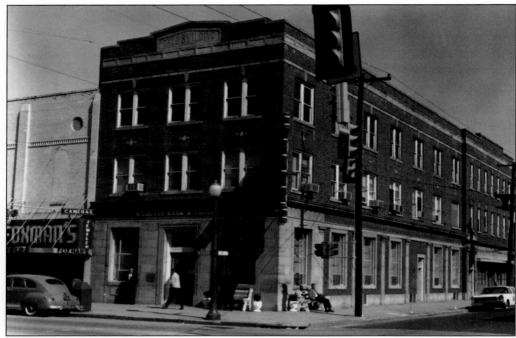

In 1961, Wachovia Bank and Trust Co. merged with the Commercial National Bank of Kinston. The downtown branch in 1966 stood on the northeast corner of Queen and Caswell Streets. (Courtesy of Heritage Place, Lenoir Community College.)

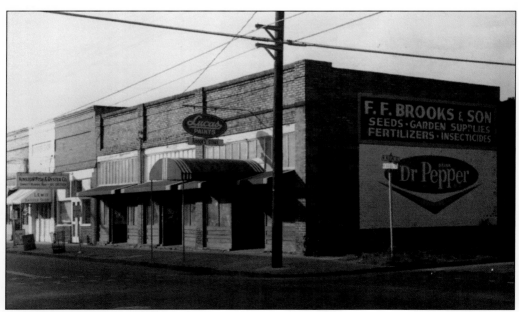

Downtown Kinston was the center of commerce with suppliers such as the F.F. Brooks and Son Store as well as many others that brought products and services to Kinstonians. (Courtesy of Heritage Place, Lenoir Community College.)

Queen Street contained many local businesses that created a very personal shopping experience for the people of Kinston. People greeted each other on the streets and the employees of the businesses knew most of their customers by name. (Courtesy of Heritage Place, Lenoir Community College.)

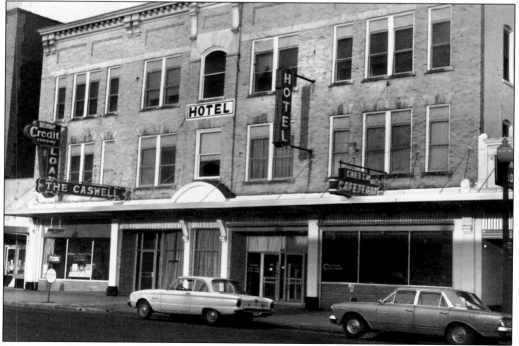

The Caswell Hotel was built after the turn of the century. However, it closed on March 18, 1967 after housing visitors to Kinston for 50 years. (Courtesy of Heritage Place, Lenoir Community College.)

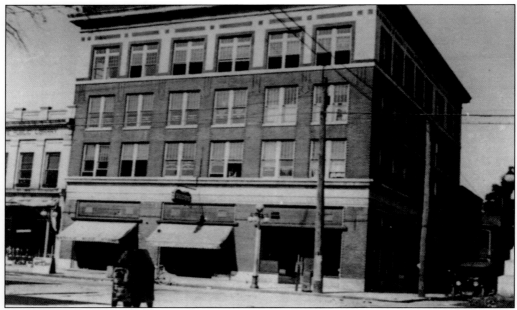

Good service, quality products, and a pleasant atmosphere characterized businesses such as this one downtown in the 1920s. (Courtesy of Heritage Place, Lenoir Community College.)

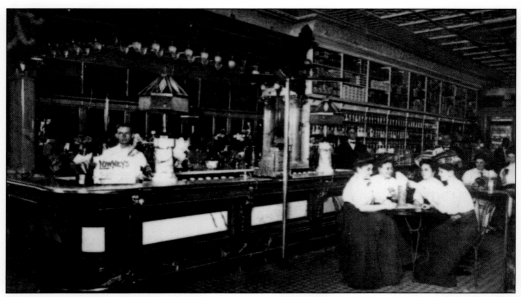

E.B. Marston's Drug Store boasted of having one of the nicest soda fountains in the state. The ladies seated, from left to right, are Flora Oettinger (Stern), Ruby Bruton, Bessie Dawson (Gray), Ruth Bond (Bizzell), Jessie Kennedy, and Minnie Lou Kelly. The men behind the counter, from left to right, are Harry Stallings, E.B. Marston, and Alfred Ashford. (Courtesy of Heritage Place, Lenoir Community College.)

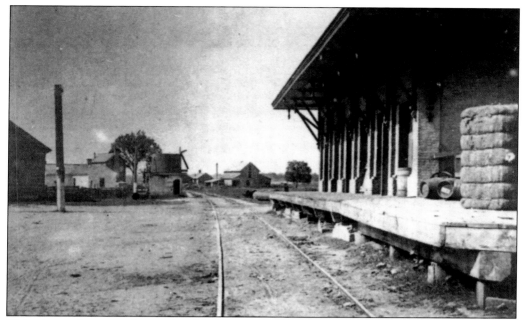

This picture shows another angle of the Kinston Railroad Station in 1884. (Courtesy of Heritage Place, Lenoir Community College.)

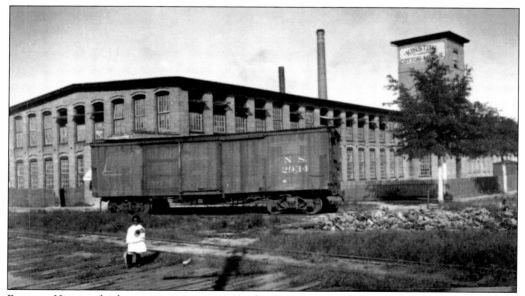

Because Kinston had gone into regression in the 1890s, some of the people of Kinston decided to build a cotton-processing plant. The Kinston Cotton Mill was established in 1898. This photo depicts the mill, which became Glenn Raven Mills after 1939. (Courtesy of Heritage Place, Lenoir Community College.)

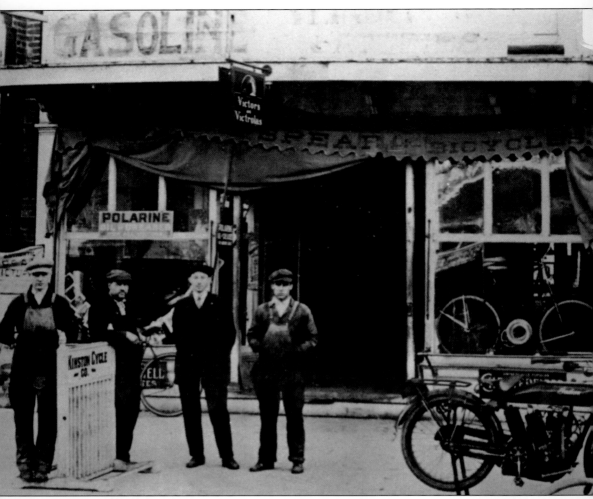

In front of Spears Sporting Goods, Inc. in 1910, Jerry French, Ike Brown, Claude Ballard, and Jesse Conway pose to have their picture taken. The Spear family began operating the sporting goods store in 1899. (Courtesy of Heritage Place, Lenoir Community College.)

The Midyette Hardware store is pictured during the 1960s before it moved to another location in 1965. (Courtesy of Heritage Place, Lenoir Community College.)

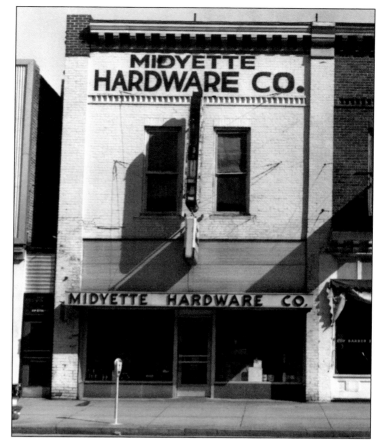

This warehouse contained the Hodge Irvine Co. (Courtesy of Heritage Place, Lenoir Community College.)

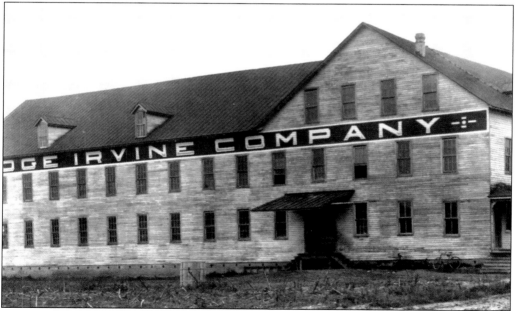

Mark Mewborn (the man in the middle with a hat in his hand) and a few other men stand in front of he grocery store of T.W. Mewborn in 1901 that was located on Queen Street. (Courtesy of Frances Lipscomb.)

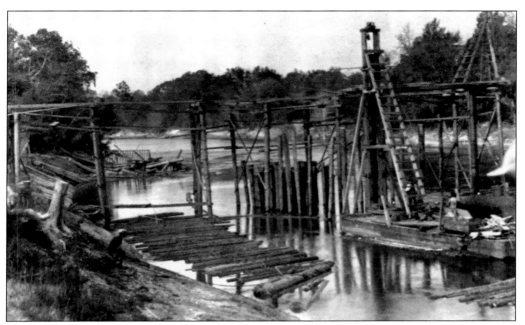

Because of its location on the Neuse River, Kinston Lumber Co. was a very successful business that provided a variety of products out of oak, ash, maple, elm, gum, poplar, cypress, and other woods. (Courtesy of Heritage Place, Lenoir Community College.)

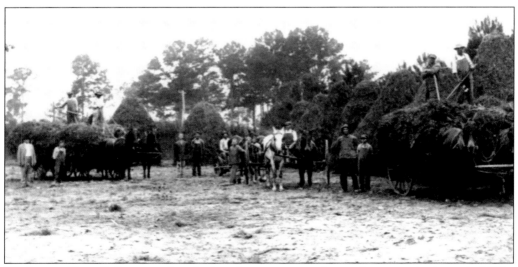

Workers at Caswell Center gather the hay that was grown during the season in the early 1900s. (Courtesy of the North Carolina Collection, the University of North Carolina at Chapel Hill.)

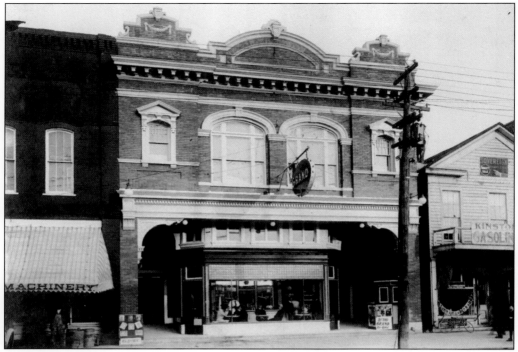

The Grand Theater, located downtown, provided Kinstonians with a nice place to relax and enjoy themselves as they watched the latest show. (Courtesy of Heritage Place, Lenoir Community College.)

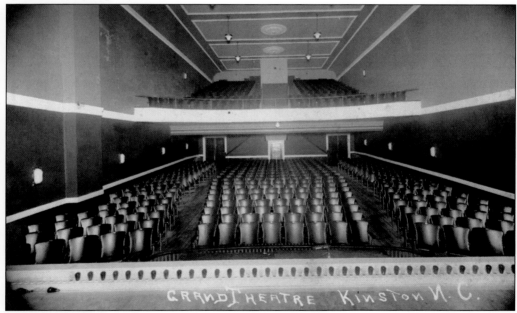

The Grand Theater certainly lived up to its name on the inside. Comfortable chairs and plenty of room created a pleasant environment to relax and have fun. (Courtesy of Heritage Place, Lenoir Community College.)

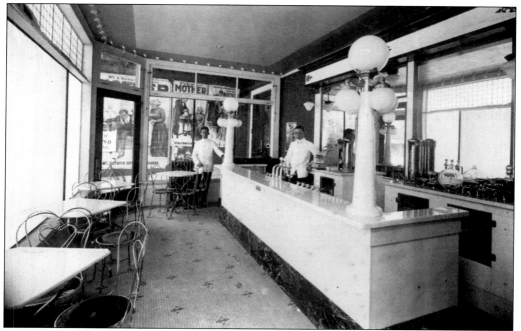

Before or after a show, everyone could enjoy a snack from the Grand Theater Soda Fountain. (Courtesy of Heritage Place, Lenoir Community College.)

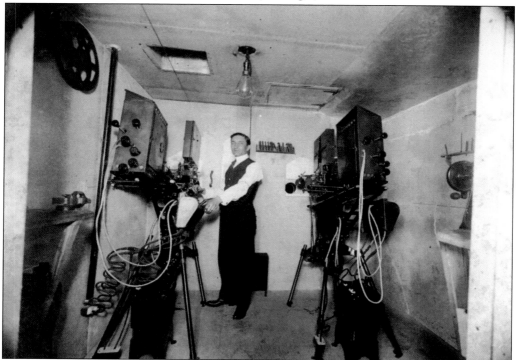

One man operated the projection room of the Grand Theater. He made sure all ran smoothly as the picture was projected. (Courtesy of Heritage Place, Lenoir Community College.)

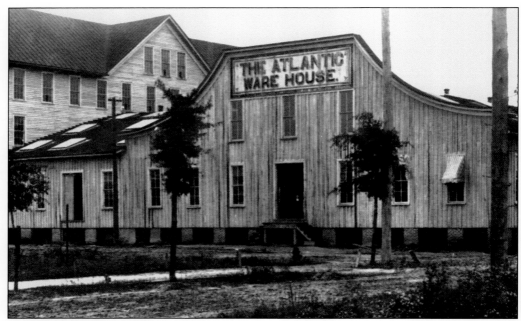

Capt. Jesse W. Grainger built the first tobacco warehouse and brought a man from Roxboro, Luther P. Tapp, to oversee the operation. Tapp was involved with this warehouse, Atlantic Warehouse, as well, which was located on the corner of Washington Avenue and Heritage Street. The Atlantic Warehouse was built by B.W. Canady, who named the warehouse Atlantic because of its location near the Atlantic Ocean. (Courtesy of Heritage Place, Lenoir Community College.)

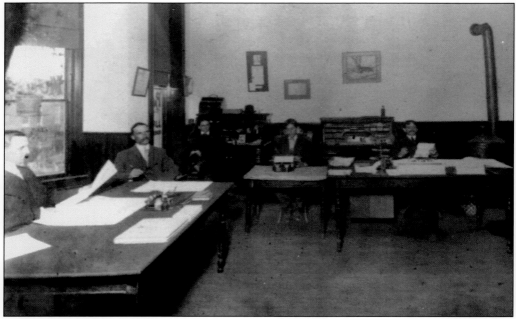

In the office of J.J. Rogers Insurance, these men work hard to take good care of their clients. (Courtesy of Heritage Place, Lenoir Community College.)

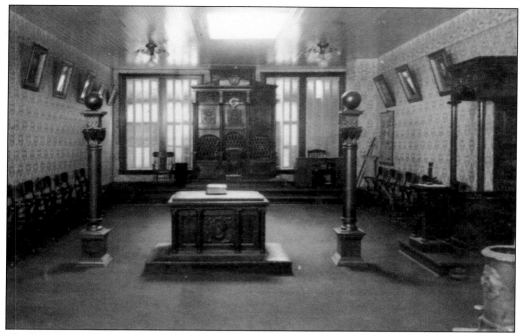

The Mason Lodge has roots that go back to Richard Caswell in the 1700s. Many prominent citizens and leaders of Kinston have been members, and the lodge has proven to be a very beneficial aspect of the community. (Courtesy of Heritage Place, Lenoir Community College.)

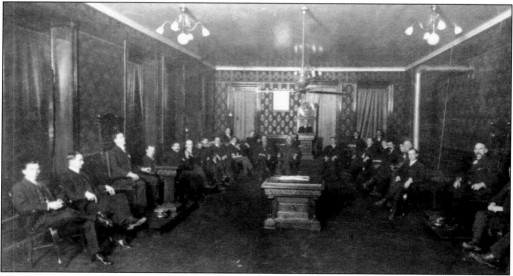

These fine gentlemen are the Knights of Pythis, an American order founded February 19, 1864, in Washington, D.C. According to Justos H. Rathbone, the order was formed when "war was in the heart of man and sorrow his home." The Kinston Lodge No. 66 was instituted September 15, 1894, with 17 charter members. In only three years, it doubled its membership. (Courtesy of Heritage Place, Lenoir Community College.)

Kinston's tobacco warehouses, such as the Eagle Warehouse, were successful in establishing the area as one of the best tobacco-marketing warehouses in eastern North Carolina. (Courtesy of Heritage Place, Lenoir Community College.)

Another addition to the farming community in Kinston was the AMC Warehouse, pictured here. (Courtesy of Heritage Place, Lenoir Community College.)

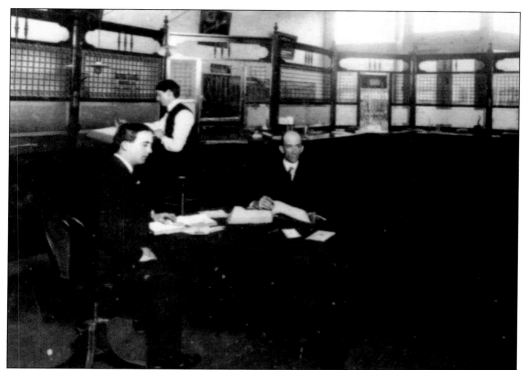

In March of 1905, W.C. (Bill) Fields and E. Becton do paperwork at their desk. (Courtesy of Heritage Place, Lenoir Community College.)

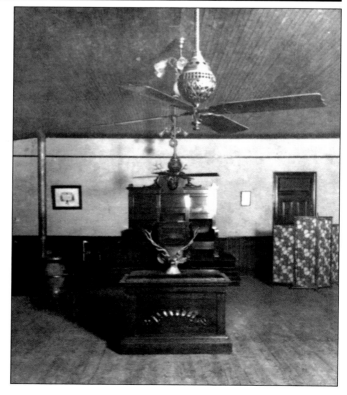

The Elk's Hall of Kinston displays an actual elk in this picture of the interior of the hall in the early 1900s. (Courtesy of Heritage Place, Lenoir Community College.)

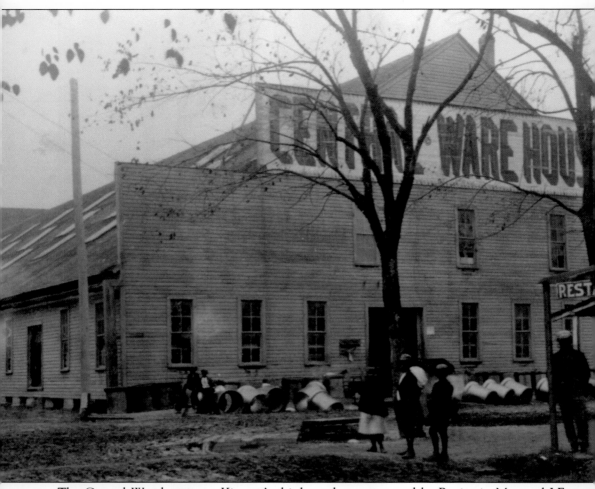

The Central Warehouse was Kinston's third warehouse operated by Benjamin May and J.F. Berry. It was located on the corner of Heritage and North Streets. (Courtesy of Heritage Place, Lenoir Community College.)

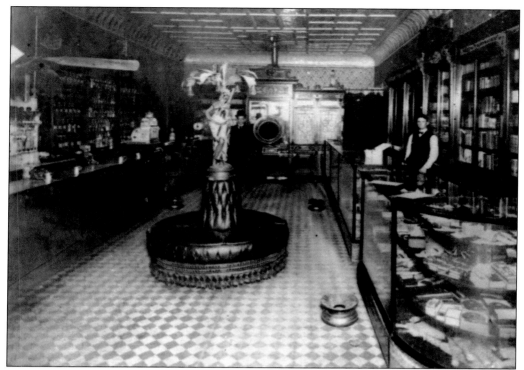

Will Hunter Jr. came to Kinston in June of 1893 at the age of 13. When he got older, he opened the Owl Drug Store in the early 1900s where Kinston citizens could go to get any kind of medicine they needed. (Courtesy of Heritage Place, Lenoir Community College.)

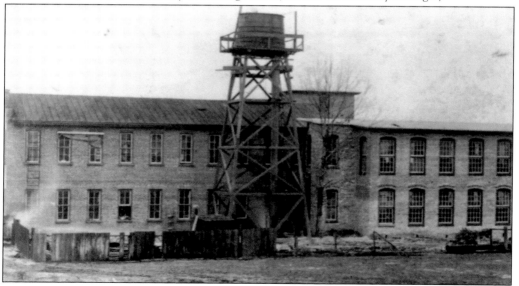

This is another view of the Orion Knitting Mills that was later known as the Kinston Cotton Mill. A public meeting was called and attendees were issued stock to the company at $50 each. The mill began in January of 1891 with 40 machines. (Courtesy of Heritage Place, Lenoir Community College.)

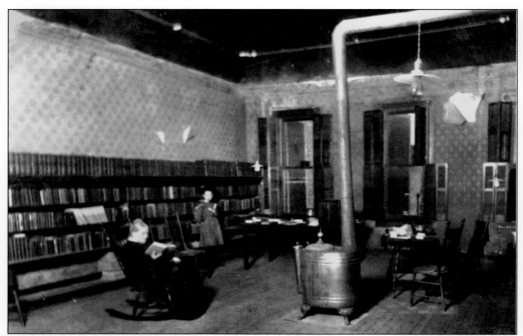

Mrs. S.M. Harding reads in the Kinston City Library with her assistant, Carolina Brock, in 1906. The library started as a literary club with Mrs. Harding serving as president. It eventually grew big enough to be established as a library. By the time this picture was taken, the library boasted over $2,000 and a membership cost of $1 a year. (Courtesy of Heritage Place, Lenoir Community College.)

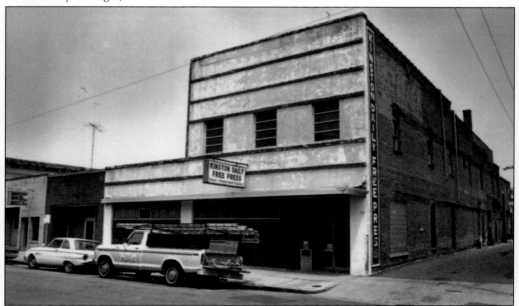

This building was home to the *Kinston Daily Free Press*. Two brothers from Wilson, Josephus and Charles Daniels, started the original *Kinston Free Press*. They sold the paper to Walter Herbert in the late 1800s. (Courtesy of Heritage Place, Lenoir Community College.)

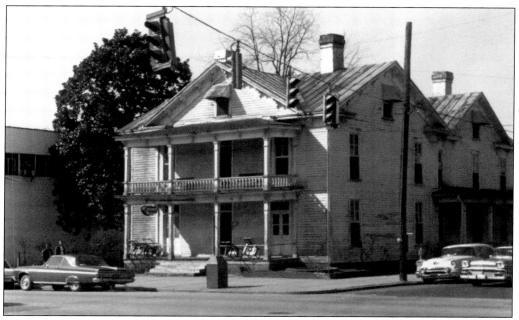

The Queen Street Inn in downtown Kinston was torn down in 1965, just a short time after this picture was taken. (Courtesy of Heritage Place, Lenoir Community College.)

Commercial flights began in Kinston with Piedmont Airlines in 1951. The first day flight initiated to New York from Kinston was on March 25, 1967. (Courtesy of Heritage Place, Lenoir Community College.)

Parrott Hospital opened in 1906. The facility originally held 20 beds but was expanded to hold 50 beds in 1926. When Lenoir Memorial Hospital began operations in 1973, Parrott hospital was no longer needed. (Courtesy of Heritage Place, Lenoir Community College.)

Kinston Country Club, pictured here in the early 1900s, has been a place for members to socialize and relax for over a century. (Courtesy of Heritage Place, Lenoir Community College.)

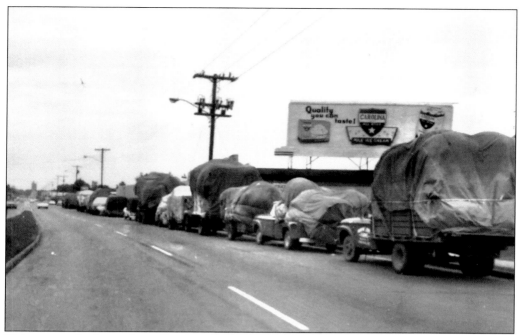

This caravan looks north on Queen Street on Slough Bridge on a hot summer day in 1967. The farmers are anxiously waiting to take their tobacco to the auction. (Courtesy of Heritage Place, Lenoir Community College.)

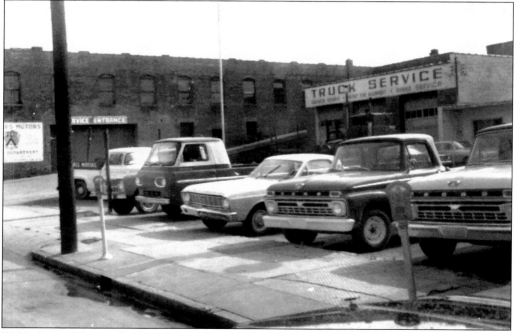

W.H. Jones Motors displayed their fine Ford products on their lot in downtown Kinston. (Courtesy of Heritage Place, Lenoir Community College.)

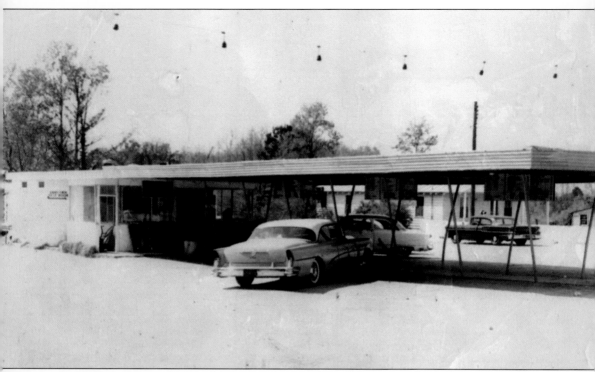

A sheriff took this picture of this local drive-in as evidence in a case against the restaurant for losing its alcohol license. The picture was to show how the restaurant operated and served its customers. (Courtesy of Jimmy and Juanita Hays.)

This building on the corner of King and Queen Streets was the former home of Richard W. King. After his death, the building served as a tavern and then turned into the Hyatt House and Hotel. (Courtesy of Wilbur King Jr.)

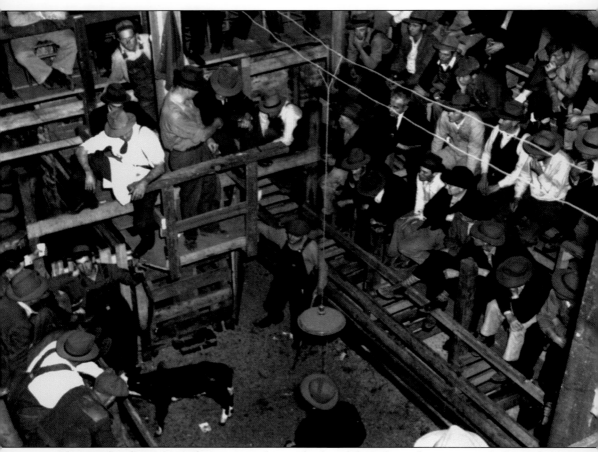

This stock sale in 1943 shows a cow being displayed for sale as the men watch from above. (Courtesy of the North Carolina Department of Archives and History.)

Seven

CELEBRATIONS

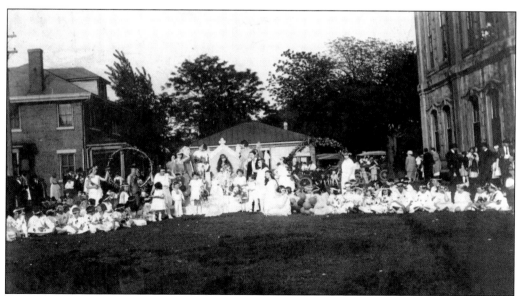

Marianna Lewis became Kinston's May Queen in the early 1900s. Both the picture above and the cover picture display the beautiful dresses and the pageant that was held to commemorate the occasion. A traditional may pole dance also took place during the event. (Courtesy of Marianna Lewis.)

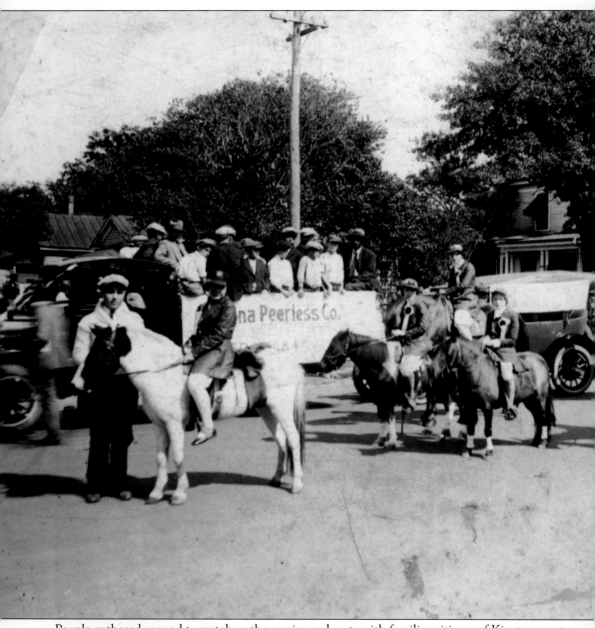

People gathered around to watch as the ponies and carts with familiar citizens of Kinston went by during a parade in the late 1920s. (Courtesy of Frances Lipscomb.)

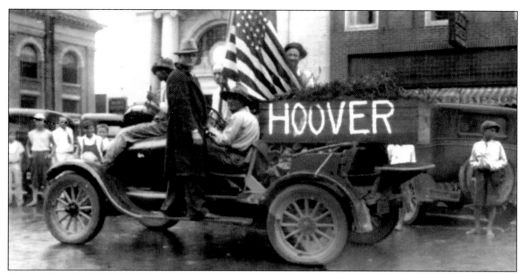

During the elections of 1928, the Republican candidate for president, Herbert Clark Hoover, campaigned in Kinston with signs, flags, and parades. He was successful in his venture; he became America's 31st president in 1929. (Courtesy of Frances Lipscomb.)

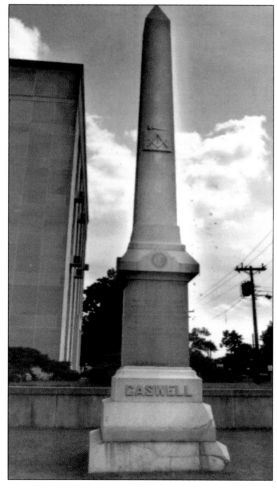

Citizens of Kinston gathered in 1881 and again in 1981 to observe the dedication of the Caswell monument in honor of Governor Richard Caswell. Having played a very important part in the history of both Kinston and North Carolina, Caswell worked as a representative in the General Assembly, attended the Second Continental Congress, and served as governor for three years. (Courtesy of Heritage Place, Lenoir Community College.)

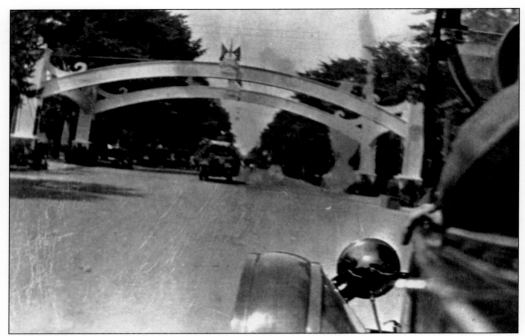

Kinston celebrated the victory of World War I with a commemorative arch and a dance held within the square on July 4, 1919. The names of those who gave their lives for the country were inscribed on the arch. The parade halted at the memorial arch on the corner of Queen and Peyton Streets as everyone paid honor to the Lenoir County boys who gave their lives for their country. (Courtesy of Heritage Place, Lenoir Community College.)

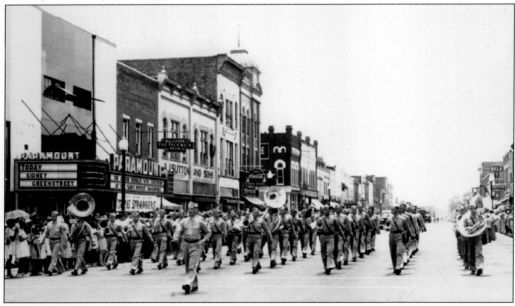

On October 18, 1962, in celebration of Kinston's 200th anniversary, soldiers parade down Queen Street in front of the Paramount Theater. That day flags, plates, and other items commemorating the event were sold. (Courtesy of Marianna Lewis.)

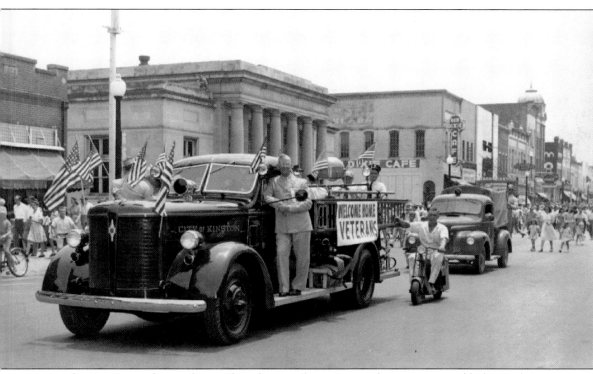

Meriwether Lewis stands on a fire truck and pauses for a picture after enjoying and helping plan this big celebration. (Courtesy of Marianna Lewis.)

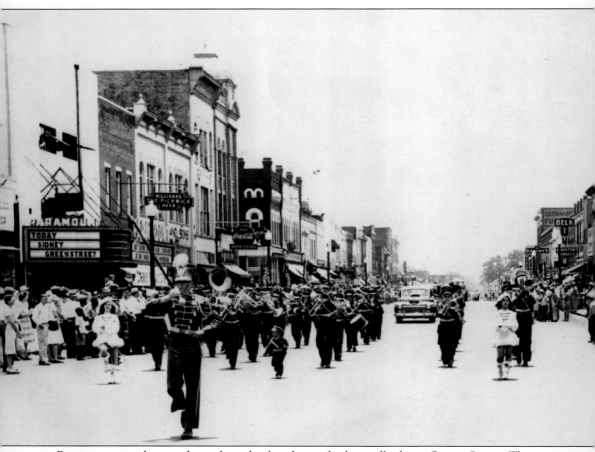

Participants in the parade, such as this band, marched proudly down Queen Street. This event brought the citizens in Kinston together to celebrate their town's 200th birthday in 1962. (Courtesy of Marianna Lewis.)